# Kodak The Art of Digital Photography: Digital Photo Design

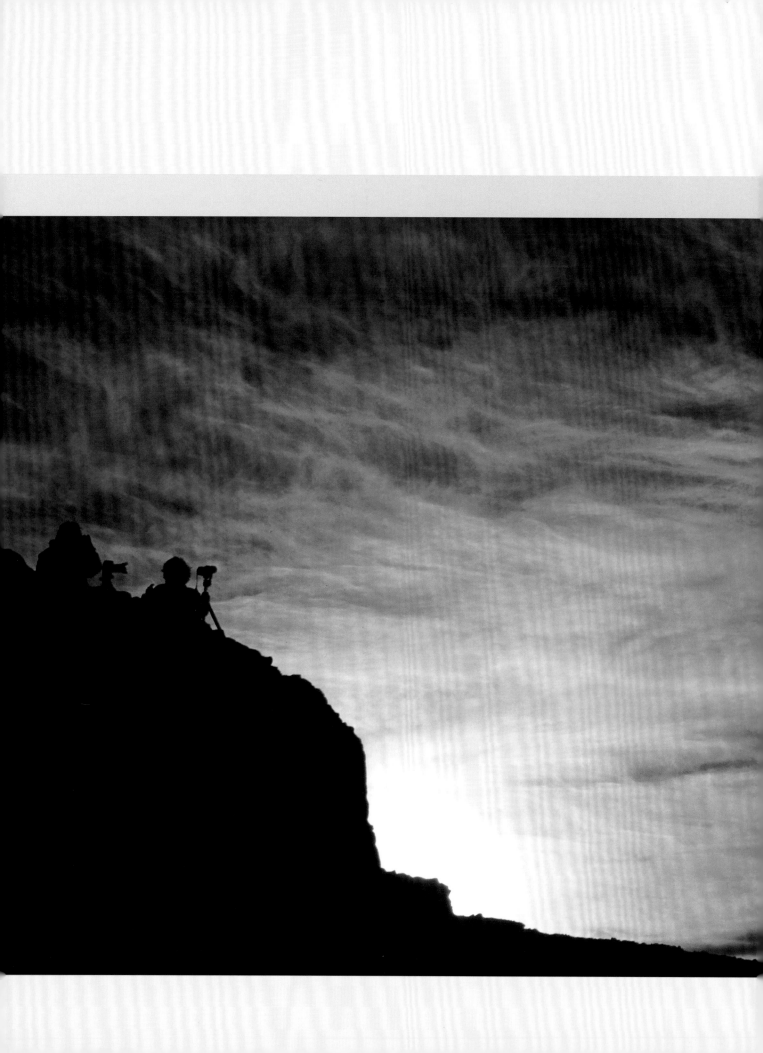

# **Kodak** The Art of Digital Photography: Digital Photo Design

## *How to Compose Winning Pictures*

paul comon

Published by Lark Books
A Division of Sterling Publishing Co.,Inc.
New York

Editor: Kara Helmkamp
Book Design and Layout: Tom Metcalf
Cover Designer: Thom Gaines
Production Director: Shannon Yokeley
Editorial Assistance: Delores Gosnell

Library of Congress Cataloging-in-Publication Data

Comon, Paul.
  Kodak, the art of digital photography. Digital photo design: how to
compose winning pictures / Paul Comon. — 1st ed.
      p. cm.
  Includes index.
  ISBN 1-57990-790-3 (pbk.)
  1. Photography—Digital techniques.  I. Title. II. Title: Digital photo
design.
  TR267.C66 2007
   775—dc22
   2006028273

10 9 8 7 6 5 4 3 2 1

First Edition

Published by Lark Books, A Division of
Sterling Publishing Co., Inc.
387 Park Avenue South, New York, N.Y. 10016

Distributed in Canada by Sterling Publishing,
c/o Canadian Manda Group, 165 Dufferin Street
Toronto, Ontario, Canada M6K 3H6

Distributed in the United Kingdom by GMC Distribution Services,
Castle Place, 166 High Street, Lewes, East Sussex, England BN7 1XU

Distributed in Australia by Capricorn Link (Australia) Pty Ltd.,
P.O. Box 704, Windsor, NSW 2756 Australia
Kodak and Kodak trade dress are tradmarks of Eastman Kodak Company used under license by Lark Books.

If you have questions or comments about this book, please contact:
Lark Books
67 Broadway
Asheville, NC 28801
(828) 253-0467

Manufactured in China

ISBN 13: 978-1-57990-790-7
ISBN 10: 1-57990-790-3

For information about custom editions, special sales, premium and corporate purchases, please contact Sterling Special Sales
Department at 800-805-5489 or specialsales@sterlingpub.com.

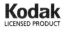

# contents

# introduction

Composition is the most fascinating aspect of photography. It is the most consistent photographic building block. Over the decades, the way we capture images keeps changing, but the way we arrange or compose them remains the same.

The art of image arrangement is never dull because each new situation is different, and presents new challenges. A pleasing picture cannot be generated by following specific rules. A well-designed image is created by considering established guidelines, then finessing them to match the situation.

I have spent a rewarding lifetime in photography, learning as I proceed. Most of my compositional knowledge is self-taught, although I had excellent guidance in college from my first photography instructor, Charles Morgan, whose accomplishments are worthy of a biography.

Since then, it has been trial and error, reading, and looking at photographs. Often when critiquing a novice's work, I glean valuable information. As we all know, teaching is one of the best ways to learn.

This book is written with the hope that the careful reader will be able to utilize my hard-earned knowledge more rapidly than I was able to collect it. Assimilate the data you discover here, emulate what you believe suits your needs, then put your own interpretation into the equation. In that way, your pictures will speak to the world of your own unique perception and view.

The best way to get started is to learn what images appeal to the largest number of viewers. What images cross language barriers, appeal to people of all age groups, and to individuals of both sexes equally? Great photographers have learned to produce that type of image. Subject content, and its proper treatment, is the most important element of any image.

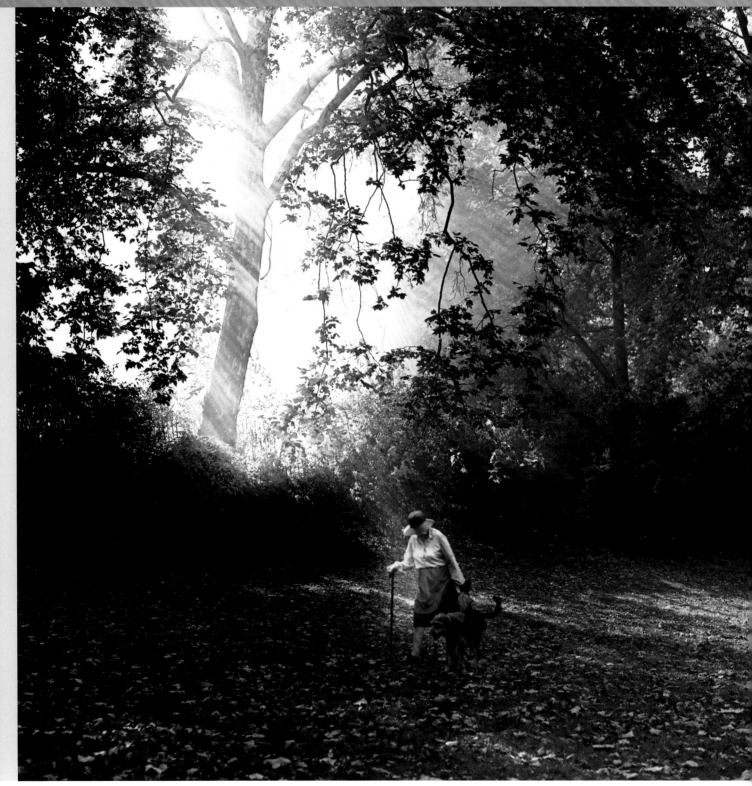

# composition defined

**ALL YOU NEED TO KNOW:** Composition is the elimination of all unnecessary elements. At first glance, this inelegant definition seems too simplistic, but if you take only one idea away from this volume, let it be that.

You will never find that definition in any dictionary and it certainly does not address all the subtleties of image arrangement, but if you practice it faithfully, most compositional problems will fall away.

We are often formed by our unique education. It was my good fortune to encounter, as my first college photographic instructor, one of those rare souls who loved what he did and took an interest in anyone willing to learn. He taught fundamentals that are with me still, but for years I thought he let me down when it came to composition. I wanted to know "all the rules of composition." He told me at my stage of development all I needed to know was: composition is the elimination of all unnecessary elements (yes, I know I am being redundant in the hope of driving this point home). I knew it could not be that simple, ignored his advice, and went on to learn all the "rules" and continued to produce moderately successful images. Later in life, as in a dream, his advice came back to me. Following his guidance, my photographs improved noticeably.

William Ockam, sometimes known as William of Occam, (and other deviations and name spellings) was born in Surrey, England, in approximately 1285. He was known as Doctor

*This image, taken at the Cliffs of Mohr in Ireland, introduces you to several techniques used to create a pleasing composition. Study this image, and as you read through the book, you will learn to recognize why this image works.*

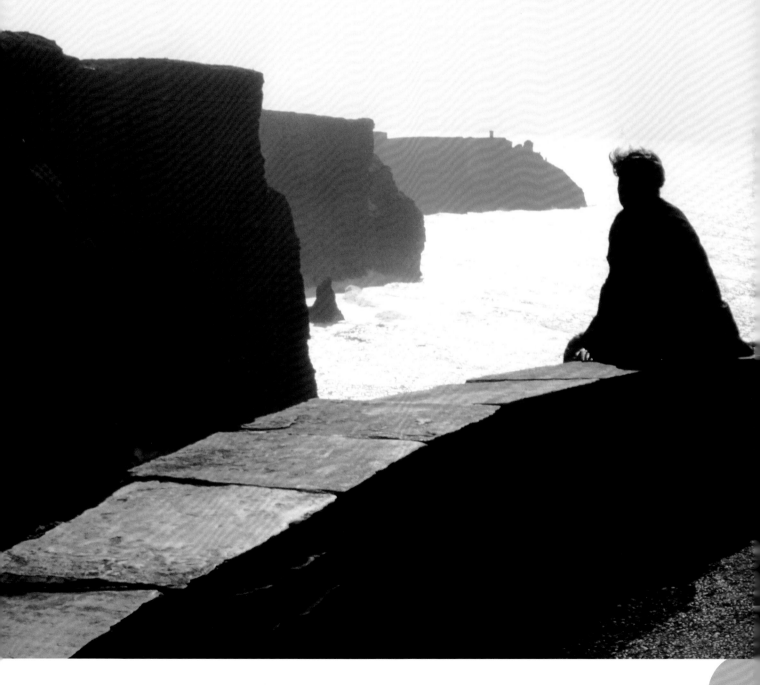

Invincibilis, or unconquerable doctor. This English philosopher and scholastic theologian is considered the greatest exponent of the nominalist school. Possibly his greatest claim to fame is a rule in science and philosophy called Ockham's (another spelling) Razor. Ockham's Razor states: when several possibilities exist, the simplest solution is the best. Is this not great advice in every walk of life? This man, who lived centuries before the discovery of photography, seems to be speaking directly to us. Uncomplicate your life; uncomplicate your photographic composition.   Some time ago an acronym was quite popular. Like many clever sayings, it became overused and with overuse it disappeared. Enough time has passed; I will use it again to reinforce my point. K. I. S. S. enjoins us to "keep it simple, stupid." Again, this was not specifically directed at composition, but it certainly could be taken as good advice for photographers who wish to improve their photographic skills.

Voila! We have been handed down three different ways of saying the same thing. From three different sources and three different periods of history we get excellent advice. This is the advice you should take to heart. When you simplify your images, the results will be more pleasing.

How do we do that? The best place to start is in the camera, and the first avenue of approach should be to move in closer. If you do not spend time composing the image before the shutter is tripped, you will consume large quantities of time trying to correct the problem later. And, there are additional advantages, in terms of image quality as well. We will go into detail later; for now, just concentrate on the fact that most pictures will improve if cropped tighter. Please do as I say, not as I did; use the razor!

Careful composition is essential in creating a successful image. Including any additional elements to example number one would lessen the image's effect.

Most of my images occur while I am traveling, and most of my traveling is done with other people. My wife and I often travel with another couple, or on a structured tour. Sightseeing accompanied by non-photographers creates an environment conducive to rushed shots. If I had allowed this type of pressure to influence me while composing this image, the results would not have been the same. It took time to decide what to exclude (notice that I said exclude, not include), to get the horizon straight, and since I was using a manual camera, determine proper focus and exposure. After all care is taken, luck can sometimes be a factor. While traveling, you encounter what I call "light de jour." When I discover a great shot near home, I When I discover a great shot near home, I will often determine what time of day will produce the best lighting for the scene and return at that time, on a day when all conditions are optimum. The quality of light is also a consideration (bright sun, haze, fog, etc.). On vacation you see potential images only once; the ability to return when conditions are perfect is a luxury not often afforded.

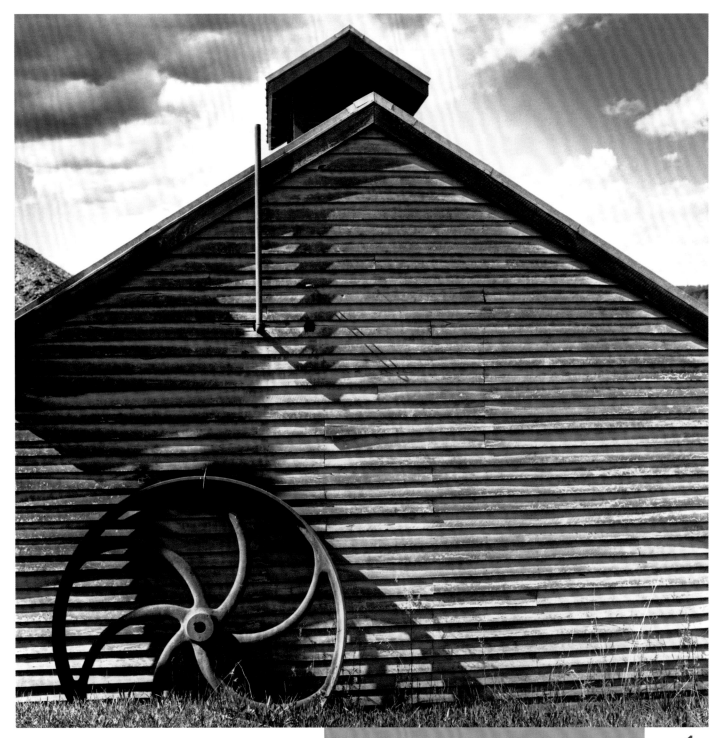

**1**

Example one was made in the gold-mine ghost town of Sovereign Hills, Australia. It was a warm, pleasant day and the tourist attraction was crowded. Often it is desirable to include a human figure in the scene to show scale and involvement. In this case, patience was required; people and/or human shadows would have detracted from this composition.

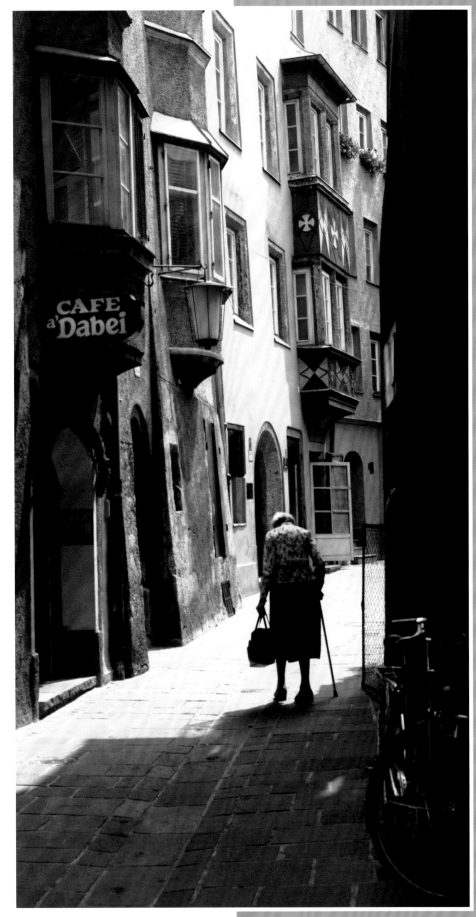

2

Conversely, example two was a grab shot. I was alone, strolling down a side street in Salzburg, Austria, when I saw an impressive composition about to unfold. I had no time to change lenses, barely time to make shutter, lens, and distance settings, then, make one exposure before the moment vanished. One instant there was a clean unadulterated scene; the next brought scores of pedestrians to corrupt the composition.

Example three shows how the picture was actually taken. In it we see that I did not have time to move in close. We also see that the lighting contrast-ratio was not what a photographer would desire. It took repeated attempts in the darkroom to produce the finished results that we see in example two. I do not begrudge the time and effort expended on this image; I am proud to have captured it, but it illustrates the difficulty-level difference between it and image number one.

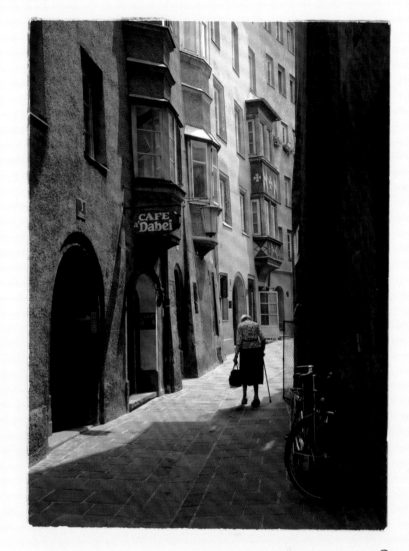

**3**

Example one was planned and carefully executed; it required little darkroom time and manipulation to create a strong print. Example two required repeated trips to the darkroom, with much deliberation in between printing sessions. Years after the original print was made, the final print evolved. And printing it correctly is not an easy task; much burning, dodging, and split-contrast printing is involved. Plan now, or pay later.

Compare the cropping in the final print to the original. We will talk about this again and again; the print format should match the image, not some factory-cut paper size. While we are looking at example two, notice how important a seemingly incidental object might be. With a piece of dark paper, or even your hand, cover the bicycle, located in the lower right-hand corner of the print. How much does it alter the print's generated emotion?

# who finds
# composition difficult?

Everyone does. Some people are strongly influenced by the left side of their brain; others favor the right. Composition combines artistic and mathematical studies; therefore, most of us have some problem performing non-dominant brain functions. The simple realization of this fact is the first step in unraveling the complexities of composition.

Stumbling blocks are eliminated when we discover that composition can be learned. Many scientifically inclined individuals incorrectly assume that composition comes easily to the artistically inclined, and the artistic people are perplexed because they may not realize that some simple understanding of compositional math is what they are lacking.

I do not wish to imply that we will be performing mathematical functions before taking each shot. We just need to know some simple, easily remembered numbers that will help make us better photographers. The people who wish to know the how-and-why will be able to delve into this fascinating system. I am not well equipped to tackle mathematics, but I find this math, which even nature embraces, is simple and intriguing. If you are interested in the simple "all you need to know" facts, you will find yourself remembering a few numbers, and then moving ahead.

It may seem that some are born with built-in compositional skills, but is that true? We have seen that composition is a facet of many occupations, skills and hobbies: decorating a cake, building a bridge, knitting a comforter, constructing a web page, designing a garden, as well as any of the more recognizable arts. The individuals who convert these skills of arrangement from other endeavors to photography are the ones who seem to be compositionally gifted. We have all picked up clues along the way; they just need to be applied.

We may find it difficult to remember "all the rules." Do not be apprehensive; there are no rules. There are recommendations and suggestions. Guidelines have been handed down to us to point us in the right direction. Think of them as rules, if you must, but rules are made to be broken. If we all follow strict rules, we would soon see a continuum of monotony; if these directions were not in place, we would be bombarded by more chaos than we currently see.

The greatest stumbling block is time, but practice makes perfect. The best way to learn photography is to take pictures. There are no mistakes; poor results are

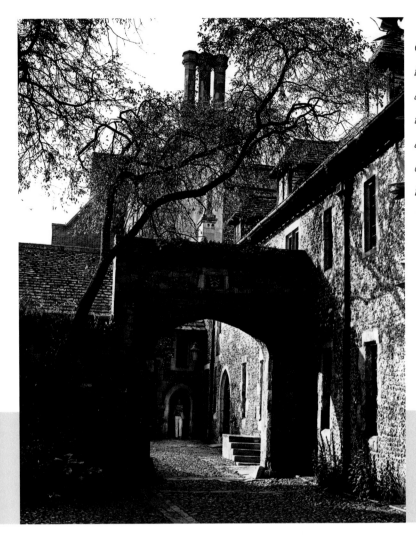

*Great composition can be found anywhere. You as the photographer must be willing to explore any view, any shape, and any situation in order to further your photographic understanding. When you travel, look for a shot that appeals to you. Any scenario, no matter how mundane or commonplace, has endless composition opportunities if you take the time and create them.*

experiences in learning. How often have we heard these platitudes? We should take a moment or two to consider how each of these sayings applies to our quest for composition.

The best way to shorten the learning curve and address the above statements is to take notes at the time the image is captured. Not the mindless recording of lens opening and shutter speed, but why and how the picture was taken. What we are after is the notation that will aid in the capture of similar images, later down the road. I will not elaborate on the procedure because meaningful data will vary from individual to individual. Instigate your own system and refine it as you progress. In time you will generate a system of notes that will be invaluable specifically to you.

One of the best compositional tools is the digital camera. It allows us to see the results soon after the shot is made. This is a great way to learn as you go, but it should not preclude note taking unless your memory is better than mine.

*Attention to detail is key in creating a good photo. The repetition of the arch shape, the several planes, and the human figure all work together to create an interesting and dynamic image.*

# human vision
# vs. camera vision

The eye-brain combination renders and records scenes in ways unlike the lens-sensor combination. The eye can take in a wide angle of view, yet can only study a narrow (2°) angle carefully. When the eye sees a distant object of interest, it zooms in to give us a detailed account of the subject. But are we actually seeing detail at a distance, or is the mind filling in details it remembers from past viewing experiences? Photographic optics will render that eagle on the distant pine tree as a tiny dot unless the lens is a strong telephoto.

The eye-brain combination may see selectively, enjoying a beautiful vista while ignoring an overturned trashcan in the foreground. It seems that modern day lenses were designed to seek out disturbing elements and render them as the sharpest object in the scene.

The camera lens and the human eye view close points of an object as larger impressions; distant parts recede. Both record the distant top of a tall building as a smaller scale, compared to the closer eye-level part of the structure. This creates perspective. However, the brain knows the building does not taper to a point and the structure does not appear to lean back away from the viewer. Only specialized, perspective control lenses can be adjusted to see like we think we do.

Most often, we change lenses to add or reduce what is included in our photograph. We know that a telephoto brings objects closer and reduces the area of the scene included. Wide-angle lenses do the opposite. But a lens change is a powerful compositional tool. Wide-angle lenses separate near objects from their background; telephoto lenses compress distances. Therefore, if we have a distracting background, a low wide-angle shot might completely eliminate the unwanted background detraction. If we are interested in showing rhythm, or a repeating pattern in a shot, a telephoto lens will be the best tool. Using it will draw similar objects closer together, heightening the effect. We will discuss this more fully in Chapter 10, and some examples will clarify the above statements, but it is important to note this human-eye to camera-lens difference.

The human viewing system can record contrast ranges far beyond a camera's sensor capabilities, resolving details instantaneously in extremely low light levels. Cameras encountering the same light intensity would probably require a time exposure to register any detail.

These are a few of the reasons why pictures taken in great hope fail. Ockam would say that the simplest, therefore the best, solution is to see as the camera sees.

## learning to see as the camera sees

First of all, we have to acknowledge that we are usually trying to depict a three-dimensional object on a two-dimensional surface (paper, monitor, TV, or projection screen.) Photography is an illusion, but what a beautiful illusion. It allows us to communicate even our innermost feelings. And photography contains no language barrier.

Consider this: a person who speaks a second language relatively well may not be able to express complex thoughts. Complexity is the forte of photography and each image is capable of conveying its theme, on different levels, to anyone who is receptive, regardless of language differences.

But how do we learn our camera's way of capturing images? Experience is the best teacher. At any stage of development, we tend to shoot the same type of image. Learn what does and does not work with each subject matter. Build on prior knowledge. If and when you explore other types of photography, you must test for best results again. However, at some time you will discover that previous lessons will help you solve new, yet similar problems. Sunsets present the same challenges as sunrises; pet photography requires some skills acquired photographing people (especially children); snow scenes will prepare you for the challenges of capturing sand dunes and vice versa.

## the film or digital debate

During the 1800s, photographers captured images on glass, then on metal plates. If great numbers of today's photographers were teleported back in time, and they had the diverse mindsets we see among us, can you imagine the heated arguments that would have occurred when images began to be stored on paper? Early adaptors would have embraced the change; purists would have fought any such advances. You might imagine some of the arguments they would have presented. Would these arguments have included issues of ethics, permanence, or corruption of the art? If you have been a photographer through the film to digital transition, this probably sounds quite familiar. At some future time, photographers will be recording images with some far better system than we can imagine today. History defines our position.

Photography is about the recording of images. How this is accomplished is a secondary consideration. We should choose a method best suited to our needs, make sure that we retain a permanent record, and have a system in place that will allow us to locate the original, when needed.

In terms of composition, digital cameras have one distinct advantage: you can observe the captured image on the screen almost immediately after the shot is recorded. If we study that image, we have a good indication of how the image will print. Film users have to wait and hope.

# color vs. back and white

Black-and-white photography is a strong medium. Think of your list of the world's most famous images. How many of them are black and white?

There is no question; we are living in a digital, color image producing society. In the early years of photography, there were only black-and-white images. Color appeared later in many different forms and processes. Improvements and environmental concerns have yielded the processes we know today.

There are some people who shoot conventional black-and-white pictures. The type of photography chosen by any given person is an indication of that person's motivation. In this area there is no right or wrong, just personal choice.

In this book, we will see many black-and-white images, because by eliminating color we eliminate an aspect that can mask the other features of the image. Even when trying to be analytical, we can be so influenced by color that we gloss over fundamental compositional building blocks.

In a good year, California wild flowers can produce vast fields that are a riot of color. Peers often show me images of California poppies that fill the frame; pictures that are beautiful as is, but would be much stronger if more effort had been exerted when the shot was exposed.

Black-and-white images have great dependency on composition fundamentals, and often the basic forms are easier to see (line, shape, etc.). Color is important; it will occupy a large portion of this compositional quest. It is so important that entire volumes, larger than this one, could be devoted exclusively to its study.

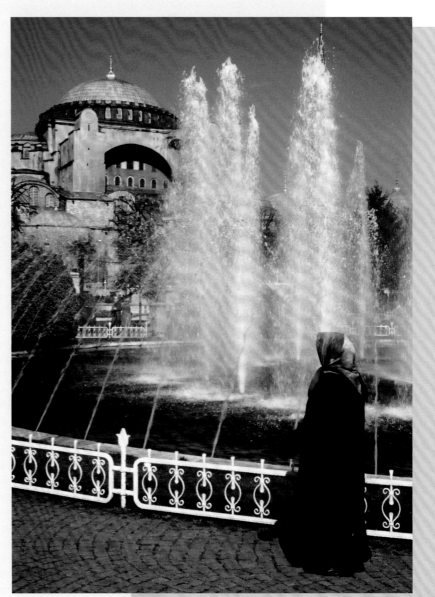

*This shot of the St. Sophia Museum in Istanbul, Turkey, takes the viewer away from the typical tourist photo to convey a different point of view. Often, thinking outside the box leads the way to a successful and intriguing composition.*

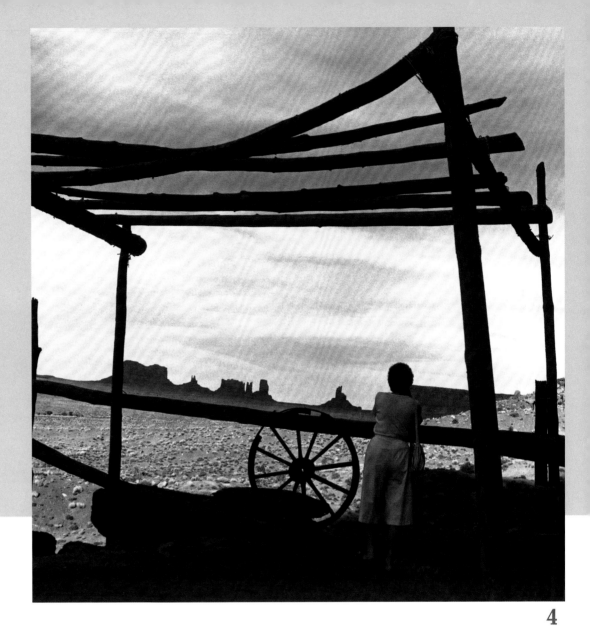

**4**

## examples of composition

The ability to take pictures is dependent upon properly functioning equipment. When I travel, I carry extra batteries, memory cards, a camera cleaning kit, my notebook and journal, a pocket size tool kit, several assorted-sized plastic bags, several shutter release cables, an adequate tripod, and a flashlight. I may also select the additional gear that each destination requires. I am always equipped for carious weather conditions.

Along with my "professional" cameras and lenses, which record my "serious" images, I take what I call my "people camera"; a small, digital point-and-shoot that goes to dinner with me and records the good times.

I am not recommending that every photographer should carry this much equipment, but no one should go on any important shoot with only one camera. Anything can happen, and the smart pho-

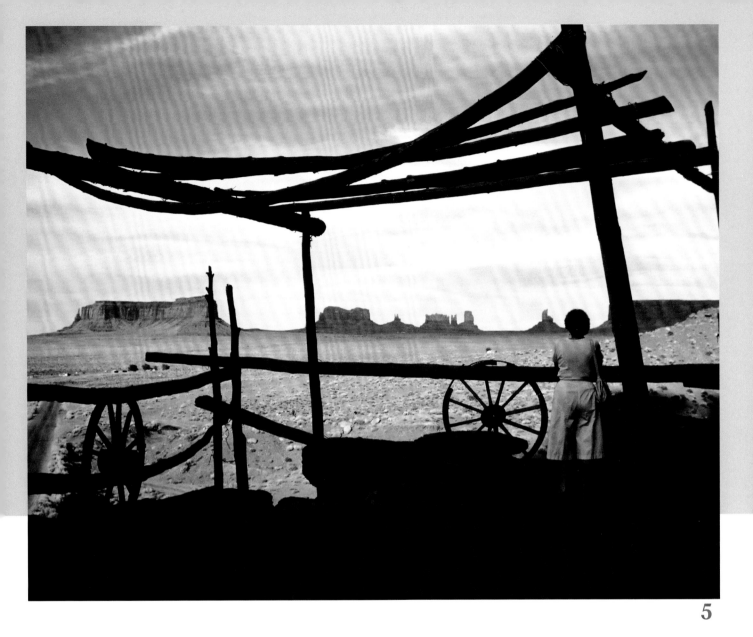

**5**

tographer should be prepared. Anyone who was ever involved in scouting already knows that.

Examples four and five are of the same scene, but the handling and execution are quite different, therefore the effect reflects these differences. The black-and-white image, by comparison, is a minimalist's execution; the color image is virtually a panorama, when viewed beside the monochromatic version of the scene.

Usually a scene will be better represented in only one form; some are monochromatic, others seem to demand multi-chromatic representation. Rarely will any given scene portray itself equally well in both mediums. At this point, subjectivity is also a factor; trying to determine right and wrong is tantamount to deciding if an apple is better than an orange.

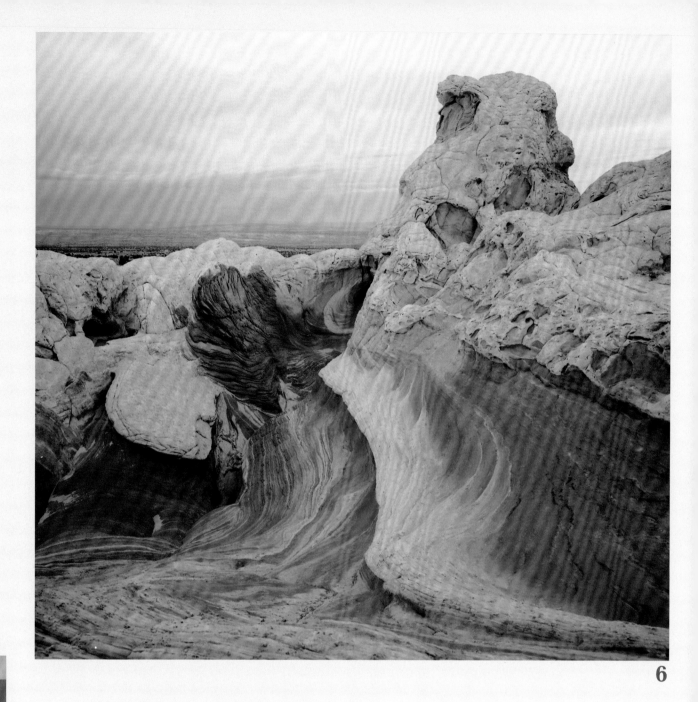

**6**

Monument Valley is a location that has been photographed repeatedly since the first camera-toting pioneers went west. It is most difficult to capture a scene like this without duplicating what predecessors have done. Part of our learning curve should include a conscientious effort to come up with a meaningful rendition that is our own. As we progress, this should be a major goal. To this end, we will revisit this theme again and again.

Examples six and seven are also of the same subject. Located in an almost inaccessible part of the state of Arizona, this formation defies description. There was no way to include a human figure, no way to indicate size, no scale by which we can judge this massive structure, and still come up with a pleasing composition. If that had been possible, we would be looking at a more successful pair of end products.

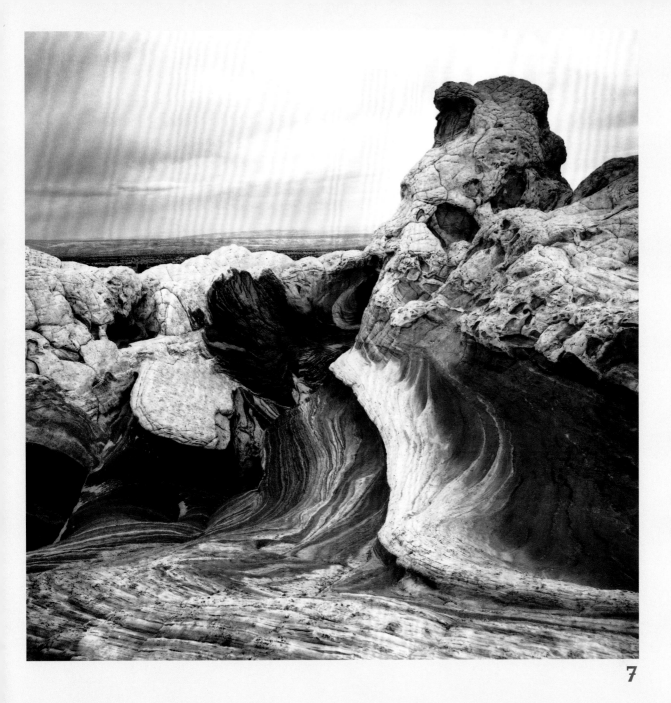

**7**

The colors found in these rock formations are like no others. People on this photographic adventure with me tell me they have been accused of altering the color when they have not. This formation is unique, its rock colors striking. I photographed it in the fading light of sunset; I photographed it before, during, and after sunrise. It could not be successfully photographed when the sun was high; the contrast ratio was too great.

When we compared prints after the trip, most viewers were amazed at how well the black-and-white representation succeeded. Usually, it is easy to determine which scene deserves a color rendering, and which does not. Even after years of experience, you cannot be positive.

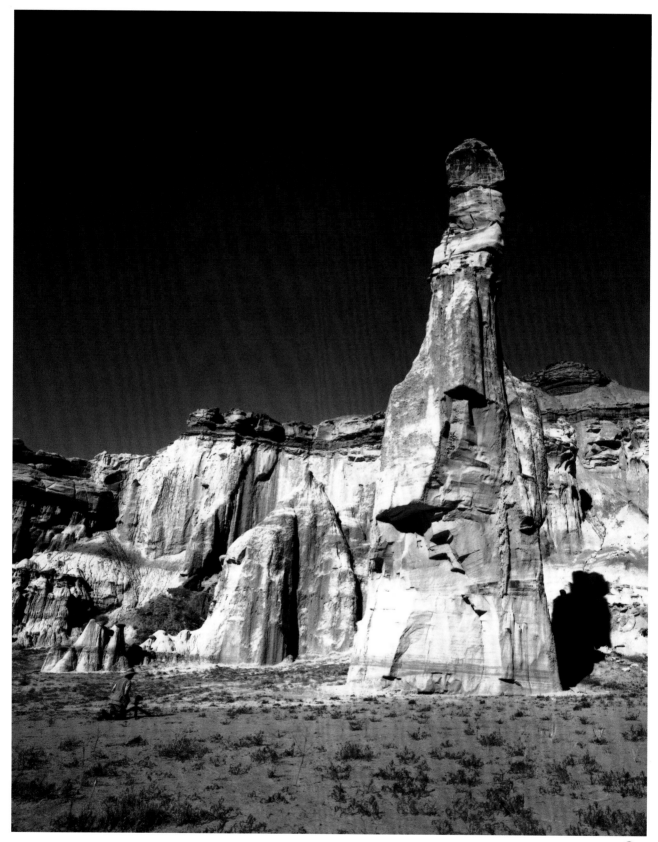

8

Example eight was created on the same trip, in the same general area. Notice the small kneeling figure in the foreground. She is photographing a wildflower. This example succeeds where examples six and seven fail; here a human figure can be compared to the massiveness of the surroundings.

Always hedge your bets, especially when you are in a location that requires great effort to access. If you return with too many images, you can just hit the delete button; if you wish you had a shot from just a slightly different angle, shame on you.

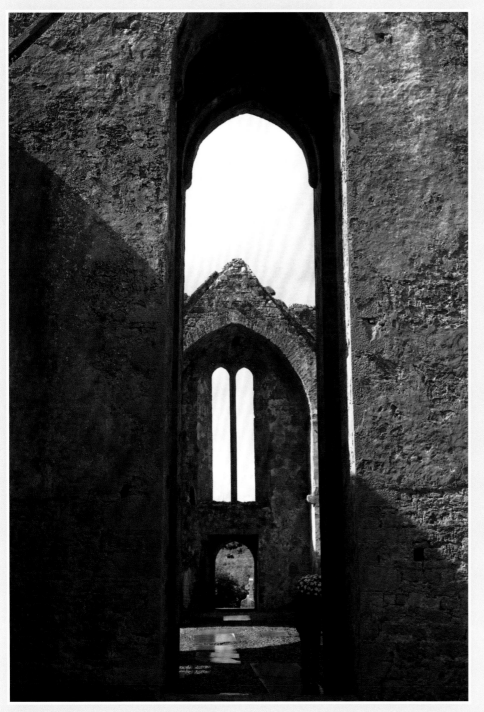

*The strong vertical lines and framing, along with the intersecting shadow, give this image a quiet tension that keeps the viewer engaged and interested.*

# formats

**2**

## ALL YOU NEED TO KNOW:

Photography evolved without much concern for standardization. If you carefully compose to fill the recordable area in the camera, you will probably not be able to include the entirety of your carefully composed subject on most standard, factory-generated paper formats. This is true if you are printing at home or sending prints to any form of printing lab. Skip this section at your own risk; the composition you diminish might potentially be your best.

This entire chapter is devoted to the relations of the various formats that photographers are faced with. Few of us are directly affected by all the interplays covered in this section of the book. The reader who wishes to understand all the format complexities should read the entire chapter; the majority may study only the formats that directly concern him or her. It should be realized that format aspect ratio inconsistencies have caused many photographers some degree of anguish. I am asked about it often enough to make me believe that it requires mentioning any time composition is discussed.

In simple words, camera-recording format and print-recording format are often in disagreement. Full-frame camera composition often leads to un-standard print sizes. But this is only the end of the world if you are not prepared for it.

It has been customary to list sizes by indicating the smaller dimension first (24 x 36 mm, 6 x 9 cm, 4 x 5 inches, 5 x 7 inches, 8 x 10 inches, etc.); but aspect ratio is the ratio of the width to the height, and the width dimension is usually stated first. Do not be disconcerted if you encounter this statement: a 4 x 6-inch print has an aspect ratio of 3 to 2.

Read on! When you grasp the full implication of these statements you may skip ahead, or delve deeply into the morass; complete understanding may simplify or complicate the equation.

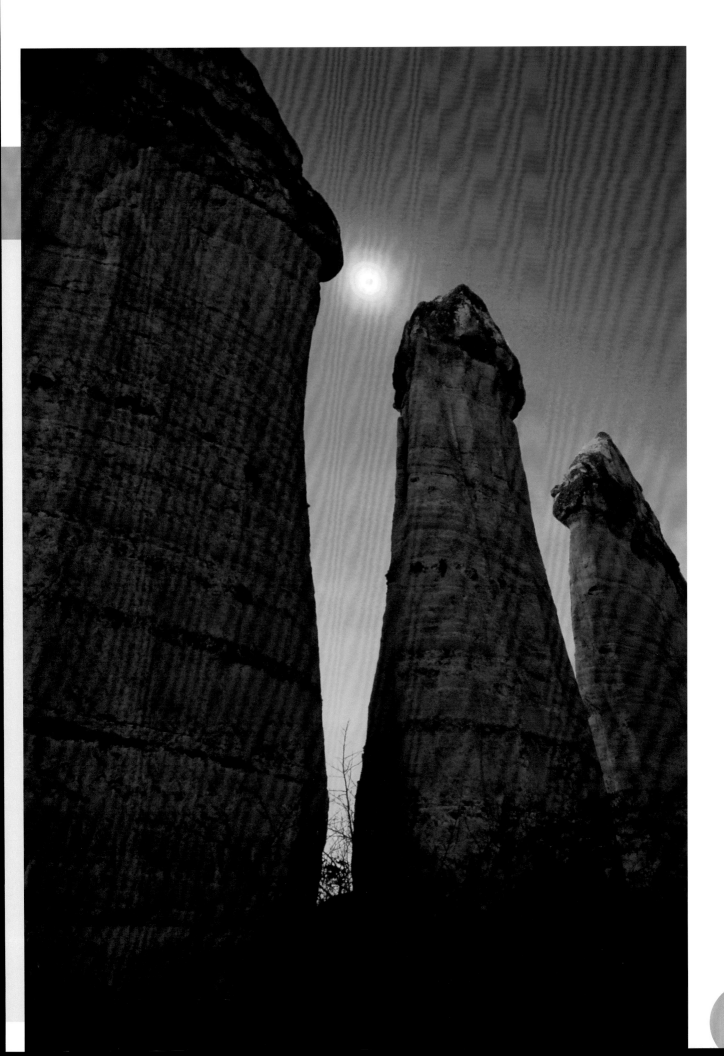

# digital formats

We know the approximate sizes of most film formats, therefore it is easy to calculate aspect ratio. Aspect ratio is the ratio of the vertical to horizontal dimensions of an image. For example, a 35mm frame (which is 24 x 36 mm) has an aspect ratio of 3 to 2. If this negative is printed on a 4 x 6-inch sheet of printing paper, you would get a perfect match because the aspect ratio of both is the same. If the same negative was printed on a sheet of 8 x 10-inch paper, cropping or a border will occur along the long dimensions of the print, because the 8 x 10 print has a 5 to 4 aspect ratio.

Digital camera manufacturers usually do not publish the dimensions of their sensors, and they are manufactured with concern to factors other than the standardization of their sizes. As technology changes, sensor sizes change, and bear in mind that it is incorrect to assume that any camera manufacturer will use the same chip in all cameras of the same camera series.

To discover the sensor size, and its aspect ratio, first consult the specifications section of the user's manual. If the information is not located there, e-mail or call the camera manufacturers technical support department. Another possible source of this data can also be found online at the various camera information centers. Also, very popular camera models have web

forums, which can also be of help. If you cannot discover the size of your camera's sensor, this is not essential for compositional considerations, but its aspect ratio is. We will see why soon.

To illustrate the complexity of the sensor size jumble, here is a partial list of some sensor sizes that are in use, or have been used:

3.4 x 4.5 mm

3.6 x 4.8 mm

4.0 x 5.3 mm

4.8 x 6.4 mm

5.3 x 7.2 mm

6.6 x 8.8 mm

15.1 x 22.7 mm

15.6 x 23.7 mm

24 x 36 mm

The above examples do not include the digital backs offered for larger cameras. These can be attached to cameras designed to utilize medium and large format film sizes.

The entire goal of this section is to point out that you must consider the end use of an image when you are composing the shot. If you carefully fill the entire LCD screen with data, you may not be able to get it onto a standard print without cropping. Also it is important to realize that most point-and-shoot camera viewfinders are inaccurate. LCD screens do not necessarily show the precise image that the sensor will record, and even expensive digital single lens reflex (D-SLR) finders are an approximation. Some D-SLR viewfinder accuracy is published. It is usually expressed in terms like 92%, 97%, etc. Refer to the sources listed above to find this information on your camera.

There is only one logical course of action—learn your camera viewfinder's idiosyncrasies. This is a process that takes time and a conscious effort, but it is not difficult and the rewards are worthwhile.

## digital paper formats

Over the years, photographic paper sizes have evolved into the formats we know today. Digital photography is the mixing pot of conventional photography, the printing industry, and the electronic revolution. When American manufacturers started offering photo-quality computer-printing paper, they offered paper sizes that were considered standard for each of the above regimes.

The result was a massive and confusing array of paper sizes, stated here in inches:

| | |
|---|---|
| 4 x 6 | 12.8 x 16.8 |
| 8 x 10 | 13 x 19 |
| 8.5 x 11 | 16 x 20 |
| 11 x 14 | 16.8 x 20.8 |
| 11.8 x 14.8 | 17 x 22 |
| 11 x 17 | 20.8 x 24.8 |

And then there are the international standard paper sizes, used in many countries outside of the U.S., stated here in millimeters:

| A Series Formats | | B Series Formats | | C Series Formats | |
|---|---|---|---|---|---|
| 4A0 | 1682 x 2378 | - | - - - | | |
| 2A0 | 1189 x 1682 | - | - - - | | |
| A0 | 841 x 1189 | B0 | 1000 x 1414 | C0 | 917 x 1297 |
| A1 | 594 x 841 | B1 | 707 x 1000 | C1 | 648 x 917 |
| A2 | 420 x 594 | B2 | 500 x 707 | C2 | 458 x 648 |
| A3 | 297 x 420 | B3 | 353 x 500 | C3 | 324 x 458 |
| A4 | 210 x 297 | B4 | 250 x 353 | C4 | 229 x 324 |
| A5 | 148 x 210 | B5 | 176 x 250 | C5 | 162 x 229 |
| A6 | 105 x 148 | B6 | 125 x 176 | C6 | 114 x 162 |
| A7 | 74 x 105 | B7 | 88 x 125 | C7 | 81 x 114 |
| A8 | 52 x 74 | B8 | 62 x 88 | C8 | 57 x 81 |
| A9 | 37 x 52 | B9 | 44 x 62 | C9 | 40 x 57 |
| A10 | 26 x 37 | B10 | 31 x 44 | C10 | 28 x 40 |

Those are only some of the paper dimensions of cut sheets that are or have been available, and there are roll sizes to be considered as well. Some combinations allow the user to make borderless prints; others do not. It is also possible to make multiple prints on one sheet of paper.

How can we handle this confusing jumble of paper sizes? The answer is simply to consider the actual dimensions of the finished print and its intended use. Consider uses such as framing, matting, placing in an album, websites, and various forms of publication.

## silver-imaging paper formats

Some of the popular print sizes over the years have been:

| INCHES | MILLIMETERS |
| --- | --- |
| 2.25 X 3.25 | 57.15 X 82.55 |
| 3.5 X 5 | 88.9 X 127 |
| 4 X 5 | 101.6 X 127 |
| 4 X 6 | 101.6 X 152.4 |
| 5 X 7 | 127 X 177.8 |
| 8 X 10 | 203.2 X 254 |
| 11 X 14 | 279.4 X 355.6 |
| 16 X 20 | 406.4 X 508 |
| 20 X 24 | 508 X 609.6 |

There are larger sizes, and there have been some special sizes like the 4 x 12-inch panorama size, and there will be other sizes in the future, but the above sizes are the most important to consider for our purposes. And as time goes on, some sizes fall in and out of favor as the standard sizes. Wallet size is 2.25 x 3.25, 3.5 x 5, and 4 x 6 are album size prints, the 5 x 7 print fits nicely on a desk and can also be hung. 8 x 10 and larger prints are usually displayed on a wall.

## how these formats interface with one another

ALL YOU NEED TO KNOW: The camera format and finished print format must agree in terms of aspect ratio, or one of two things will occur. Either the image will need to be cropped, or the full area of the paper cannot be utilized. For example, a full frame 35mm negative will yield an area of approximately 7 x 10 or 8 x 12, but not 8 x 10.

Aspect ratio is determined by placing one dimension over the other to form a fraction. Then each of the two numbers is reduced to its lowest whole number. For example 24 x 36 mm would be expressed as an aspect ratio of 3 to 2.

Edward Weston shot with an 8 x10 camera and made 8 x 10-inch contact prints. He never had to worry about aspect ratio, but he had no opportunity to crop. The exact opposite is true for most of us today.

*Probably the most common print size is the 8 x 10 (203.2 x 254 mm). Printing on it, for most digital files, requires some cropping.*

Digital sensor formats do not necessarily match digital paper size aspect ratios.

Silver-halide and digital boundaries are merging, thus causing even greater aspect ratio discrepancies to exist. If you are wise, you will plan for every eventuality. Scanned film may be printed digitally and digital files are sometimes printed on silver-halide paper. If a tightly composed image fills the entire frame, some less-than-wonderful consequences may occur. If much excess space is included in a scene, the result will be of lesser quality.

Regardless of where you store your data, in digital files or on film, learn how all of the components that you work with interface. Think about filling the frame before you make the exposure and remember that thought process when viewing the finished result. One way to learn is by trial and error, but it is better to have more trial, less error. Taking notes is a fine way to shorten this learning experience.

## how these formats relate to the geometrical shapes

Most images, photographic or otherwise, are intended to be viewed in a rectangular format. However, there are other shapes that can be utilized to contain our finished work. The shapes we will be considering are the circle, the oval, the square, and the above-mentioned rectangle. Often these containers are used for special effects. Whether we use them intentionally for that purpose or not, they have symbolic implications. The shape can affect any viewer's mood, sophisticated or otherwise. And we will also see that the most complicated of these forms, the rectangle, can have interesting variations.

The rectangle, as defined by Webster's Dictionary, is "any four-sided plane figure with right angles, and thus its opposite sides equal and parallel." As we all know, the square fits this description, but has four equal sides. However, in composition, the square is somewhat limiting and confining; the rectangle offers more variation, thus more freedom. This most commonly used geometrical shape is exciting, because its aspect ratio can, and should, be varied to match the composition, style, and mood of each individual photograph.

## examples

Sometimes you see a wonderful scene, make the best exposure settings, and compose to the best of your ability, yet when you see the finished results, the image is lacking. Example nine is a prime example, one of many that we will all take in our respective lifetimes. When do you work and rework the print? When do you give up and move on? These are judgment calls; sometimes you put the image aside and move on, then get another idea, revisit the problem image, and try again. Even this, however, does not guarantee success. There is no clear-cut solution. Ansel Adams died leaving thousands of negatives that he never printed.

As it was taken, this image offers multiple challenges. It is too contrasty in some areas and too flat in others, but its major defect is that it does not focus the viewer's attention on the image concept I had hoped to capture.

Example ten is the final outcome. The image contrast is controlled by burning, dodging, and multiple-contrast printing. What really makes the image work is radical cropping. Standard paper sizes will not accommodate the exact aspect ratio of this scene. There was only one

9

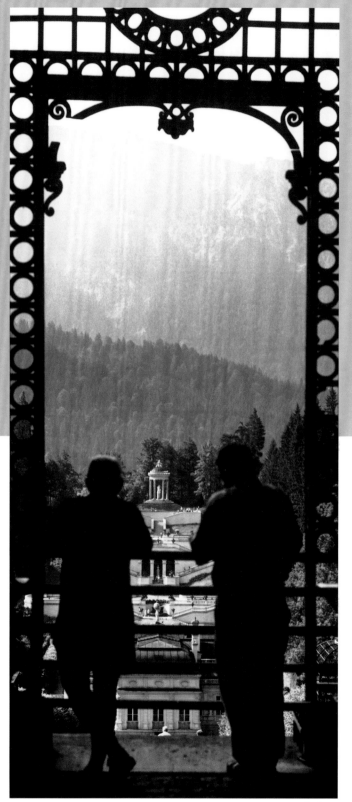

10

possible solution; print for the full image height and trim the print's sides. This example illustrates that another cliché, "Think outside the box," is probably more apropo to photographic composition than the saying's originator could have possibly imagined. Our image box must be changeable.

For our purposes, we can consider a square and a circle together. A composition contained inside a circle would have to be composed on a square portion of the image format. If you stretch your imagination, you could consider a circle as a square with severely rounded corners. Using that same logic, an oval is a rectangle with rounded corners.

*Few photographers create oval prints today, however the advantages of the oval can be utilized when making a rectangular print.*

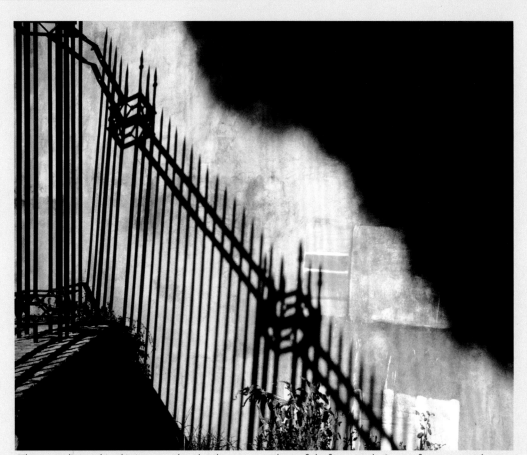

*The strong diagonal in this image makes the almost square shape of the frame work. Square frames are tricky as they give equal importance to each side of the image. As a photographer, think about the shape of your final frame when composing an image.*

Few images have ever been placed within a circle. When you try to conjure up such an image, very few come to mind. Probably the most famous of these images are by Sandro Botticelli, painted in the 1480's. In the 1590's Caravaggio also created circular images, but neither painter created many round format works. The oval, when used as a compositional frame, was commonly used in times past. Few of us would consider using an oval today, unless we were trying to produce an image resembling a period piece.

The square format cameras has caused some photographers to compose in that one-to-one aspect ratio, but often images captured as a square are cropped to become a rectangle. The photographer using this format knows he will usually be cropping for the final result.

The various cameras that have rectangular image receptors are the ones that often cause the most problems. This is due to the fact that photographers wish to record rectangular images on rectangular paper and that would be all well and good if both had the same aspect ratio, but as we have seen, they usually do not.

*I captured this California coastline-redwood image in a private campsite area called Lime Kiln.*
*It is one of many examples that I present to you, illustrating that we need not conform to any*
*manufacturer's concept of an acceptable paper aspect ratio. Also, note that even if you do not*
*notice the solitary seated figure at first glance, it becomes quite important when finally noticed.*
*Consider the size of the woman. Would a significantly larger image of a person add to or*
*detract from the overall effect of this composition?*

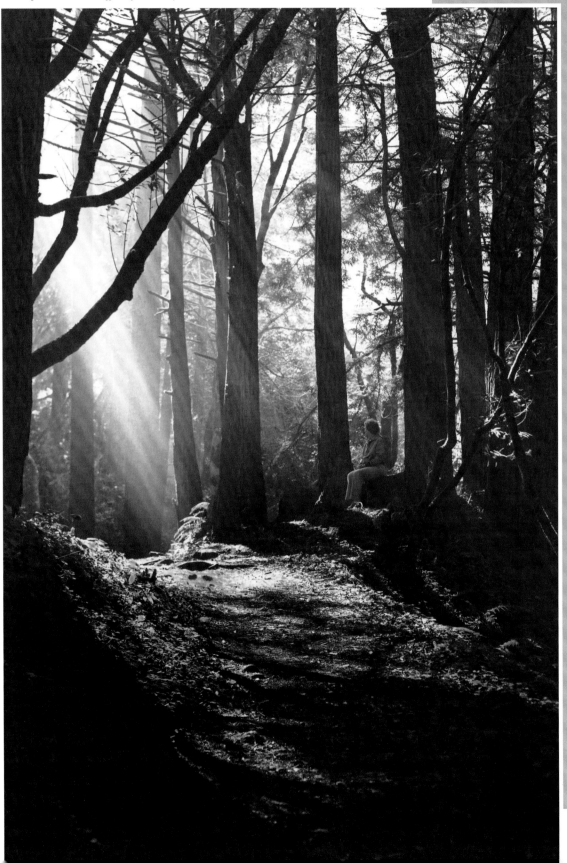

# geometrical frames

**ALL YOU NEED TO KNOW:** We will focus mainly on the composition occurring within a rectangular frame. Other shapes have been used in the past, and may be used again, but even in the days when these frames were used, the rectangle was the favored one. Knowing why the other shapes were used will give us a better insight into the reasons why the rectangular shaped image is so popular, thus rounding out our understanding.

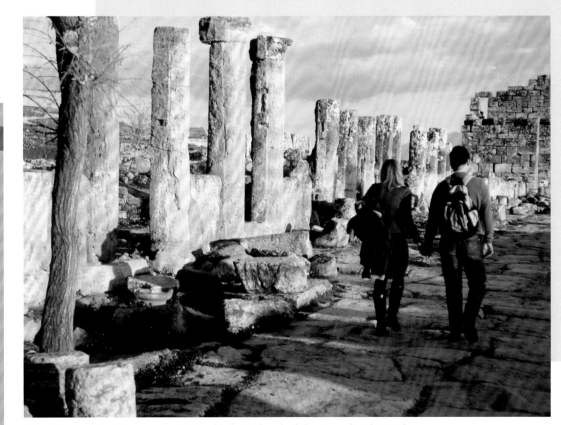

*The columns of these Roman ruins in Pamukkale, Turkey, lead the viewer directly into the image and to the main subject of the couple walking hand in hand.*

# the circle

The circle is the least used of the four geometrical shapes that we will discuss. The circle is all encompassing. The eye naturally travels its perimeter in an unrestricted movement. Because there is no variation, its simplicity generates monotony. There are few compositions that will fit properly within the confines of a circle. It takes a masterful artist to create a great image confined by a round frame. How many famous pictures can you call to mind that are framed in this manner? How many pictures of any degree of importance can you conjure up that have a round format?

Although they are usually printed on a rectangular sheet of paper, one type of photographic image would benefit from a round frame. Images shot with so-called fisheye lenses produce round images. These images have a unique fascination, partially due to the way they can render an otherwise common scene in an entirely different perspective.

Composing through a fisheye lens presents multiple problems. As previously stated, it is difficult to find a scene that will perfectly fit in a round frame. If the horizontal dimension is treated correctly, there is usually too much sky and foreground in the scene. If the area covers the top-to-bottom object correctly, there is usually too much side-to-side area included.

It is also difficult to properly practice the image placement techniques necessary for strong composition within a circle. We will discuss image placement, at great length, in Chapter Seven. Most subjects are placed in the center of fisheye compositions, thus reducing the possibility of maximum impact.

*N.Y. Tower Brooklyn Bridge*

# the oval

In the past there were many oval images. Vertical ovals were used effectively in portrait photography, especially when the image was of a single person. The oval shape confines the eye movement to the subject of the photograph. There are no corners for a wandering eye to explore. Used correctly, this technique yielded an impressive effect. It kept the viewer focused on the image's main theme and created a cohesive product.

The oval, or its modern evolution, is widely used today by photographers who know how to take advantage of the ellipse's most powerful benefit. Most individuals who view prints are unaware that this technique has added additional impact to the image they are viewing.

The human eye is drawn to the lighter parts of any image. In the digital darkroom, the print can be easily manipulated using a technique known as burning down the corners. This simply means that the corners of the print are darkened, thus forcing the viewer's eye to concentrate on the central print area. Light sky areas often create monotony; careful darkening of the top corners of the print will often relieve some of this unwanted effect. The intelligent printer knows how much of this burning down is adequate; if any manipulation is obvious, it is detrimental.

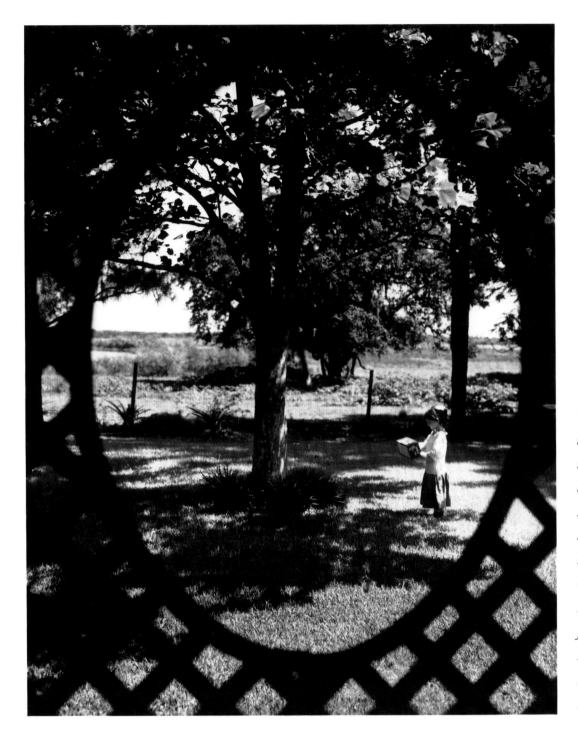

*This is an example of how a rectangle can be reconfigured to impart the feeling and mood of an oval. This effect is exacted, in a subtle way, by darkening the four corners of the print. Digital printing techniques are easy to master. Once learned, the corner darkening procedure is easy to repeat on future images, and often it strengthens the composition by forcing the viewer's eye to linger longer in the frame.*

Also, the bottom corners of the print should often be burned in. This is especially true when there is little subject matter in the bottom portion of the picture area. The bottom of the print can usually be darkened more than the top corners because, in most cases, the technique is less noticeable there.

Corner darkening, done in a subtle and gradual way, keeps the viewer's eye in the center print viewing area. Holding the interest of the observer for the longest possible time is the goal of any good print maker. So, by some stretch of the imagination, we can see that the rectangle with darkened corners has been converted into an oval.

*A square frame offers a neutral representation of a scene. In this case, neither the implications of dominant verticals or horizontals apply.*

## the square

The square has been with us for quite some time. It is the second most widely used photographic-composition frame. Its use is more difficult because it does not set the tone as a rectangle does. When we discuss the rectangle, we will talk about how the picture mood is controlled by the long dimension of the print. Because the square has sides of equal dimension, the mood indicator is neutral. When we study the rectangle, it will become apparent how these two shapes, that share some commonality, differ in that respect.

If the sides of the frame are neutral, the internal composition must state its own tone. Equal vertical and horizontal elements yield a static and stable container in which we may place a composition that echoes that mood. Going back to our goal of simplification, some subjects fit nicely in a square format print, others do not. If all the vital image elements can be concisely contained in a square without any wasted space in the print area, that is the print format of choice. If the subject matter has dimensions that are not equal, a rectangle is probably a better choice.

# the rectangle

This most common compositional format is actually two formats in one. We must consider the horizontal rectangle as a separate entity from the vertical rectangle. But, before we study them individually, let us see what common features they contain.

Most subjects are such that they are nicely contained in a rectangle of some sort. The most common vertical image is that of a single person portrait; most scenic images are horizontal in nature. By making the format agree with the subject we can more precisely fill the frame with only vital information.

Again, we should make the print format conform to the configuration of the subject. The most common error committed by beginning photographers is not turning the camera to the vertical position when photographing a single person. Carrying this thought one step further, many correctly composed images will not conform to factory-cut paper sizes. Compositional impact can often be enhanced when paper is trimmed. Consider the panorama. Panoramic cameras have been in existence since the early days of photography. There were even so-called banquet cameras that were designed to photograph large groups of people. These early attempts at format-altering express the need to make the image and print format agree.

Today, we still have panoramic cameras and digital photography has its counterpart, stitching programs. By shooting several overlapping shots, the photographer can then stitch them together in the computer to produce panoramas of any degree (including 360˚). Piecing images together to form panoramas was difficult before digital stitching became available. To achieve moderate success, the camera had to be mounted on a leveled tripod, the nodal point of the lens directly over the point of rotation, and each exposure carefully controlled. Yet, after all these precautions, the failure rate was high. Now images captured digitally, or scanned, can produce flawless panoramas with little trouble.

The fact that unique formats were generated reinforce my point; just because we have a camera with a given aspect ratio and image viewing media of another aspect ratio does not mean that we should be content to place our every image in confining uniform boxes. Let the image express itself fully by designing conforming windows.

We said that the long dimension of the rectangle determines the mood and image tone. Thus, a horizontal format denotes peacefulness, repose, and/or sweeping grandeur. Most nature scenes unfold in the horizontal; when we sleep we are usually in a horizontal position, so

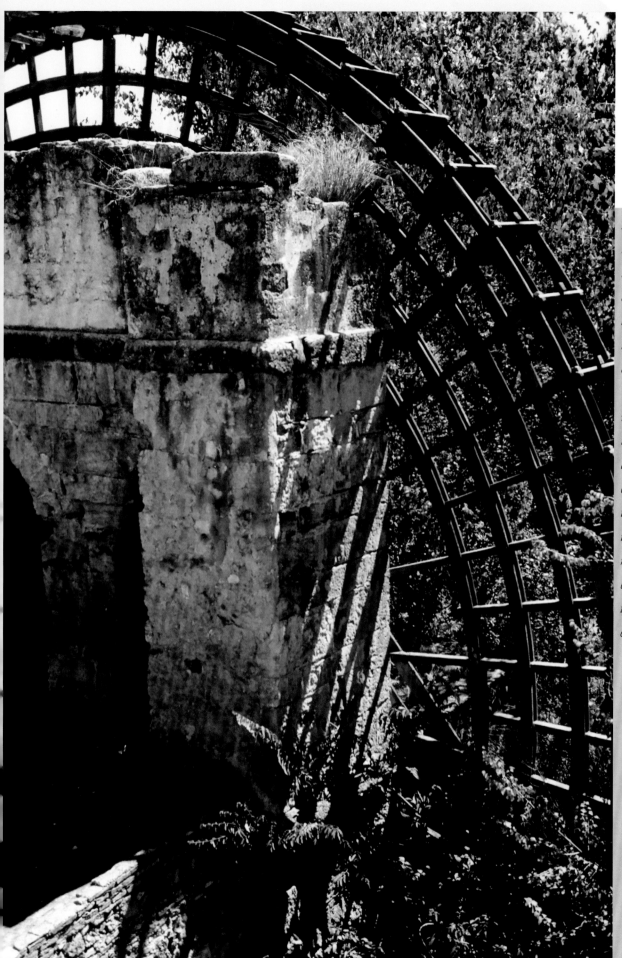

A rectangle, when shot head-on, can be a monotonous subject. Usually they are better handled obliquely, and they can become more interesting if contrasted against another shape. This ancient Spanish water wheel structure consists primarily of a rectangle and a circle. These two shapes complement one another. If this rectangle was shot by itself, it still would have made an interesting study, but the circular augmentation greatly enhances the overall effect.

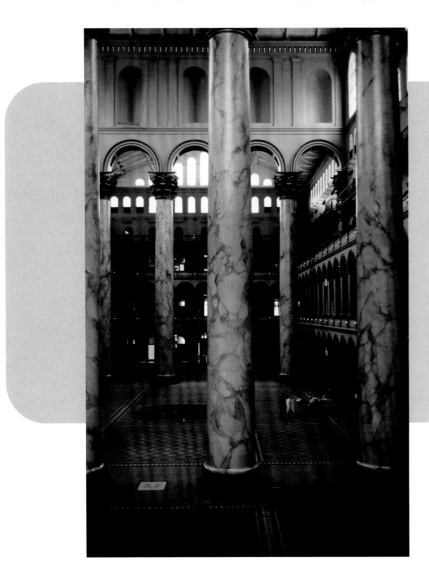

you can see that defining the meaning of a horizontal composition is merely expressing what every human being knows, but probably has never considered.

Vertical objects are said to be stately. Why are most statues tall? Have you ever seen the portrait of a president captured while he was in a reclining position? Does a mountain seem more imposing when presented as a single peak in a vertical composition, or when expressed as part of a range of mountains, in a horizontal image?

So we agree, the most reasonable format for image containment is a rectangle. And, the tightest composition will be obtained if we crop the paper to fit the image, not the other way around. The other alternative is to compose so that the image conforms to some factory cut paper size. We are considering examples that border on the theoretical; most of us will usually take the easy way out and conform. But, it is good to realize what we are giving up when we do so.

As we are considering rectangles of different aspect ratios, it is time to ask ourselves if there is any rectangle with better proportions than others. Can the proportions of the frame play a part in creating more pleasing composition? The answer is yes; there is a rectangle of such proportions; it is called the golden rectangle.

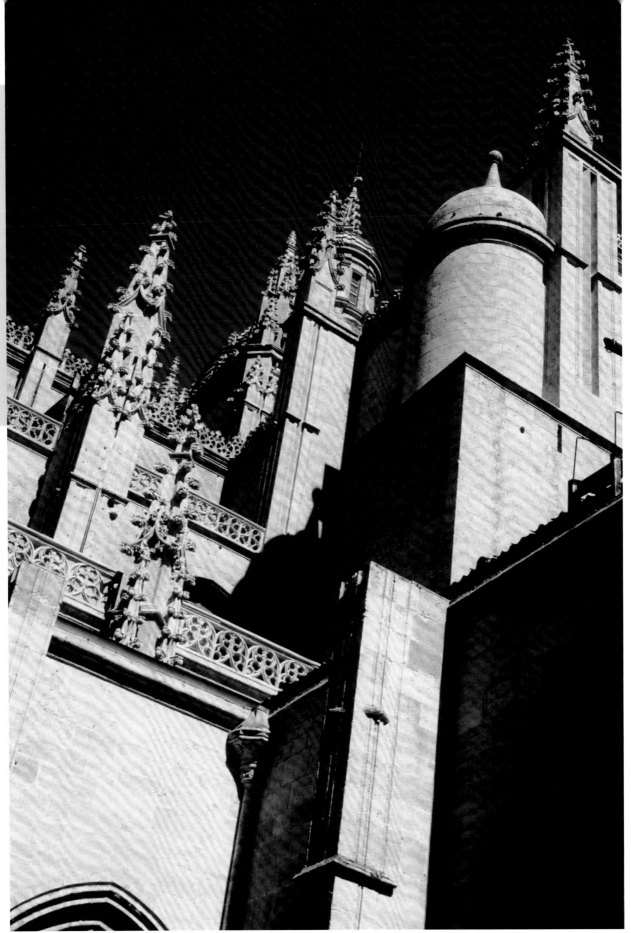

*Again, here we see the importance the vertical lines impart. The spires of this cathedral in Cordoba, Spain, are bound by the sky, giving the viewer's eye a reason to return to the main part of the image and study intersecting points.*

## a history:
## the fibonacci numbers

**ALL YOU NEED TO KNOW:** This subject deserves careful scrutiny by anyone who is not familiar with the golden rectangle concept. It is a far-reaching idea that has been a guiding force in the building blocks that govern most of the arts. It must be understood by anyone who is even mildly interested in improving his or her compositional skills. The principal that generates the golden rectangle will also become a wonderful guide to image placement. Therefore, if you are not interested in utilizing its principles, consider what you are missing, before you choose to ignore this most helpful tool. It is probably impossible to follow this concept exclusively, but the informed image creator should take advantage of its benefits whenever possible. It is acceptable to choose an alternative for justifiable reasons; it is unwise to ignore it due to ignorance.

Leonardo Fibonacci (c 1170 - c 1240), also known as Leonardo of Pisa, discovered a series of numbers that made him famous in his native Italy and throughout the world. This number sequence looks amazingly simple, yet we will see far - reaching implications as we study this series that is formed in an elementary way. He started out with the number 1 then added 1, then continued adding the sum of the previous numbers to get each succeeding number: 1, 1, 2, 3, 5, 8, 13, 21, 34, 55 and so on. We could continue adding preceding sums, but we have already gone far enough with the Fibonacci sequence for our purpose.

This number sequence has many interesting properties, and is widely used in mathematics, often consulted by architects, is the keystone of some musical compositions, employed by the world's greatest artists, and even exhibits properties found in nature. Some mathematicians claim they are the building blocks of the universe. We will not argue that last point, but we will see that they are vital to the study of composition.

4

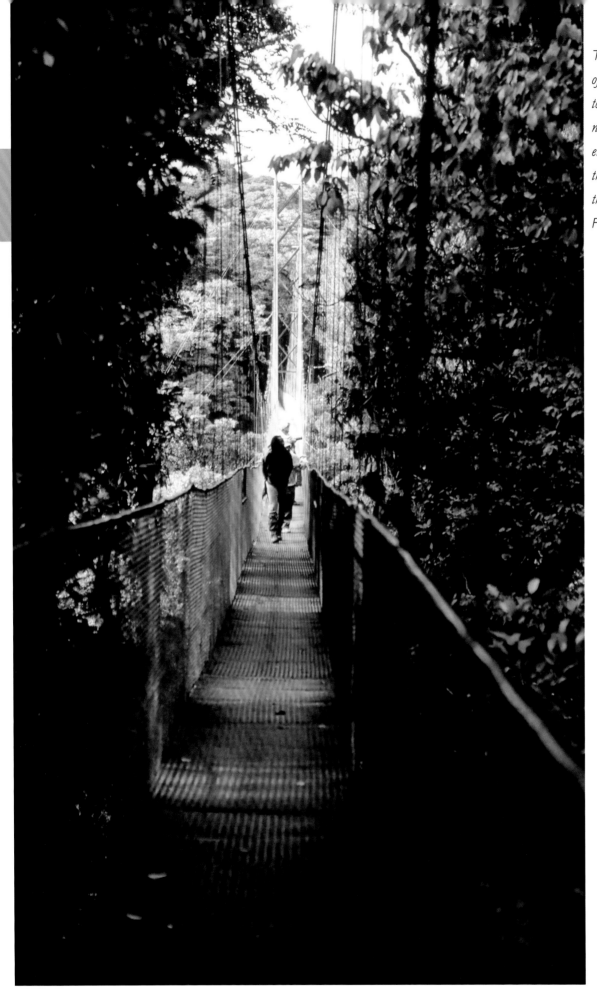

The golden rectangle is one of the most pleasing shapes to compose within. This nearly golden composition emphasizes the verticals of the trees and the depth of the scene in the Cloud Forest of Costa Rica.

Luca Pacioli taught his most famous student, Leonardo da Vinci, the principles of De Divina Proportione. Da Vinci employed the principle during his entire career, studying it, testing it, and probably becoming obsessed by it. It is said that he studied human cadavers and took precise measurements, testing and proving the theory. Leonardo da Vinci's Vitruvian Man contains measurement after measurement, which conforms to the magical ratio. Most of his works, including the Mona Lisa, also include these divine proportions.

So let us delve into the numbers and see what they are all about. After that, we will learn some more interesting things about the number sequence and a number, called phi, that can be obtained by simple multiplication using the Fibonacci Numbers. Then we will discover how the numbers form the building blocks for the divine proportions, the golden mean, the golden segment, and related compositional tools.

## number games

Many interesting mathematical applications can be wrought from manipulations of this number sequence, and mathematicians have been doing just that for centuries. To reinforce this statement, I will cite just one of many. Incidentally, this is not important to us in our quest for compositional understanding, but it indicates the convoluted nature hidden behind a simple façade. If we take any Fibonacci number (let us arbitrarily use the number 13) and multiply it by 2, then subtract the Fibonacci number that occurs two steps before it (5), we would get an answer that told us the next number in the sequence (21). 2 x 13 – 5 = 21. Numbers games like this abound.

Here is the number that is important to us. If we begin dividing one Fibonacci number by the previous one, we see that all the quotients yield a unique number: 1.618. While it is true that the smaller numbers do not precisely produce this quotient, as the numbers progress in value this is the number we can always expect.

# nature and
# the fibonacci numbers

If we look at a pinecone and study it carefully, we will discover that we can see spirals. There are two of them moving in opposite directions. Logic tells us the number of spirals in each direction should be equal. They are not; there are five in one direction and eight in the other.

The fruit of an unpeeled pineapple is covered with bumps. If we look closely, we will see spiral shapes taking form. The pineapple has eight spirals in one direction and 13 in the other.

Now let us consider the cornflower. Look closely and discover spirals among the florets inside the flower. Counting the spirals, we discover 13 in one direction and 21 in the other direction.

A daisy also contains spirals. There we discover 21 and 34. The amazing pattern is emerging. All these plant-life objects, and many more, are conforming to the Fibonacci Number sequence.

Vincent van Gogh was obsessed by the sunflower. What did he see in this flower that fascinated him so? If we study sunflowers as he did, we would discover spirals, 55 and 89. If we had extended our Fibonacci Number sequence beyond 34 we would have discovered that 55 then 89 would have been the next numbers in the sequence.

Plant life is not the only place in nature where the Fibonacci Numbers are found. The growth in a nautilus shell is controlled by them.

In 1202, Leonardo Fibonacci wrote a treatise concerning the reproductive behavior of rabbits. He found that under his controlled set of conditions, they reproduced in numbers that precisely conformed to his famous sequence. There are more incidences in nature that conform, or the other way around, but the point is well made. The Fibonacci Numbers are somehow a window to the wonders of nature.

## why they are a powerful compositional tool

The origin of the golden mean is lost to us, but we do know that the ancient Greeks and Egyptians knew how to employ its use. It is not known if an artistic person is naturally drawn to it because of its pleasing effect, or rather copying forms from the natural world around her. The ancients may have known some formula not unlike the ones known to us today. There are multiple ways to construct the golden mean; some use simple math, some take the algebraic approach, others rely upon geometry. When actually learning how to construct rectangles that conform to the divine proportions, we will take the advice of Ockham.

The Egyptians had a class of mathematical technicians whose title roughly translates "rope measurers." These were the individuals responsible for the dimensioning of the pyramids and other structures. Where did they learn their craft? What earlier civilization taught them about the golden mean?

The ancient Greeks were aware of the golden mean. Countless sculptures, amphorae, and even the Acropolis attest to this fact. Herodotus mentioned the Egyptian use of it. In later times, it was used in the designs for the Parthenon, the Venetian Church of St. Mark, and the U. N. Building in New York. Throughout the ages, the western world has constructed, carved, and crafted objects employing the golden mean as their proportional tool.

Pythagoras used the golden mean. It influenced his formation of what we call the Pythagorean Musical Scale. The golden scale follows the Fibonacci Numbers closely. It has been said that Bela Bartok used the golden mean in many of his compositions. Claude Debussy was also enthralled with the golden ratio. He captured its proportions in many of his works, including his *Prelude to the Afternoon of a Fawn.*

By now you should be convinced that aesthetics and mathematics are related. Just a simple bit of math will help us construct better images. We will learn how to construct a golden rectangle now and later we will utilize these numbers to control placement inside the frame.

# how to construct the golden rectangle

To construct a golden rectangle, multiply the smaller dimension of the print by 1.618, or divide the longer dimension by that number. It is that simple. Now you see that we are not being supplied with many lab-produced prints, factory cut papers, or even cut-out mats that conform to the golden rectangle. 4 x 6 (A6) and 8 x 12 (A4) prints come the closest to conforming.

There are several solutions. We can trim the print to conform. We can choose the format closest to the proper proportions, or just be aware of the situation and continue producing images as we did in the past. We must also realize that every composition does not conform to the golden mean. Some images will demand unique proportions; if that is the case, individual demands take precedent over other considerations.

It will be shown, in subsequent chapters, that we have ultimate control inside the image frame. The golden ratio is a tool that is completely at our disposal. We can use it in its intended way, or avoid it, to make individual statements.

**A**

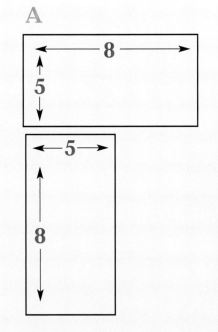

**B**

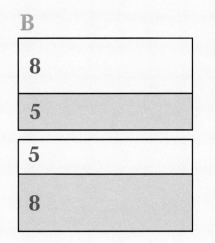

**C**

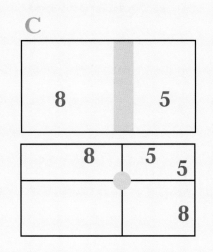

*A, B, and C are illustrations of the way the Fibonacci sequence of numbers help us construct an image. A indicates pleasing format proportions. B illustrates the proper places to position the horizon, all other things permitting. C establishes one position that a subject would assume to become the center of interest. These examples are based on the 5 to 8 ratio. Working with any of the Fibonacci ratios (2:3, 3:5, 8:13, etc.) would produce approximately the same results. Remember, the larger the numbers, the closer they come to achieving the "perfect" ratio.*

# lines

5

**ALL YOU NEED TO KNOW:** Lines are elements of great importance. Strong lines will lead the viewer to the point of most importance, like a roadmap. They set the mood for most images. Lines may function as a division between other picture elements, or stand alone as the prime picture element. Lines may also act as symbols that infer meanings that are not readily apparent. If an image contains a line, the viewer's eye will follow it. The knowledgeable photographer will use this fact to his or her great advantage. Each type of line makes a unique statement; we will study the different aspects of lines, then consider the facts that are common to all lines.

## the horizon

The horizon is the line most often encountered in outdoor photographs. Virtually every scenic shot contains one. Often ignored, it nevertheless plays some very important roles. Let us look at the ways that the horizon line influences our composition.

It should go without saying that the horizon should always be parallel with the top and bottom edge of the frame. Three of the most common reasons for slanting horizons are: excited photographers who, so enthralled with some aspect of the scene, forget all else; an astigmatism problem (in the photographer's eye) can skew the horizon; and some lenses (extremely wide angle and fisheye) produce curved horizon lines. The edges of curved horizon lines should intersect both the left and right image-edges at equidistant points.

A horizon line, placed in the center of the image, divides the image in half. The person placing the horizon there is in

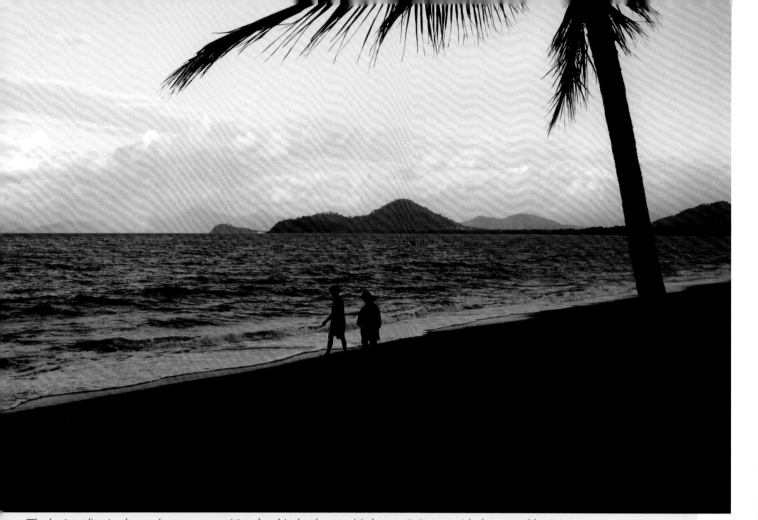

*The horizon line is almost always a compositional tool in landscapes. Make sure it is even with the top and bottom of your frame. A crooked horizon line is a quick way to lose your viewer's interest.*

jeopardy of producing two equally important pictures on one page. There are few legitimate reasons for doing so. Even the classic scene of the mountain and its reflection in foreground water should not be divided equally. Decide whether the mountain or the reflection is the dominant subject, and give that part of the image the most space in your composition.

The horizon line imparts a feeling of restfulness to the image, and the lower in the frame, the more this is so. A picture containing a horizon line that is placed near the top of the image creates a heavier feeling. Knowing these two facts is well and good, but we should place the horizon line where it is needed to complement the statement that our image is making.

Stated another way, a low horizon emphasizes height, while a high horizon emphasizes distance and/or depth. The position of the horizon can be used to emphasize the character of the landscape, and it should be placed in the position that augments the intended theme.

A viewer will automatically assume that the larger of the two picture divisions is the more important, and this is almost always the case. But in some instances, we can create dramatic effects by doing the opposite. Think analytically before placing any horizontal line.

Completely eliminating the horizon forces the eye to concentrate on foreground and/or mid-range objects. No horizon is a better choice than a poorly placed one when photographing landscapes. However, when the sky or airborne objects are the subject of the image, some foreground is highly advisable. Subjects such as rainbows, sunsets, auroras, and the like, are better presented with some terra firma used as an anchor. Naturally, this does not apply to astronomical images of stars, planets, comets, and deep-space objects. They are not recognized as needing a relationship with our planet.

But if we have some freedom to place the horizon, where should we position it? If you wish to take the simplistic approach, you will follow the rule of thirds. One-third of the picture area would be devoted to sky, and two-thirds to earth, or vice versa. Those who divide picture areas in thirds do better than photographers adhering to no structure, but there is an even more pleasing solution.

In Chapter Four, we learned about the Fibonacci Numbers, and I promised that we would see them again. Well, here they are (but not for the last time). The two of these numbers that will be of greatest importance to us will be the numbers five and eight. If we place our horizon line at that top-to-bottom spot that has an 8 to 5 ratio, or a 5 to 3 ratio (the larger for the area of most importance, the smaller for the lesser), we are composing our image in compliance with the golden section. The choice is yours; place the horizon randomly, use the fast and dirty rule of thirds, or emulate Leonardo de Vinci.

## horizontal lines

What was said about horizon lines applies to horizontal lines. Long horizontals create a feeling of restfulness, space, and expansiveness. Horizontal lines may be broken or solid, bold or faint, few or many. How we use them is our decision.

Solid horizontal lines usually have more impact than broken ones. However, if an object interrupts a horizontal line, the eye will unconsciously connect the segments. Sometimes this creates an additional bit of excitement to the composition.

*The vertical lines in this composition all balance the one strong horizontal line, that being the horizon. Do not underestimate the power of a subtle line.*

Bold lines naturally make bold statements. The person laying out a shot should be careful where bold horizontal lines are placed. A bold horizontal line placed at the top of an image may create a top-heavy feeling. A bold horizontal should never be placed in the center of the frame, because, like the horizon line placed there, it divides the image in half, giving both halves the same importance, and therefore dividing the viewer's attention.

Faint horizontal lines can be of great importance, depending on their relationship with other picture elements.

If a faint horizontal line is the only noticeable feature, it will play a dominant role. If lines of other types are dominant, the faint line looses its importance.

Numerous horizontal lines accentuate the feelings common to the single horizontal. If there are more of these, and they are of equal or greater boldness to their competition, they will set the theme.

Multiple horizontal lines are usually more powerful if they conform to one another. A series of bold ones can make a powerful statement. Regardless of whether they were placed there (as in a set-up shot), or discovered in the field, they will most likely dominate the composition.

Usually a composition with strong horizontal line(s) requires a horizontal-format frame to support the composition.

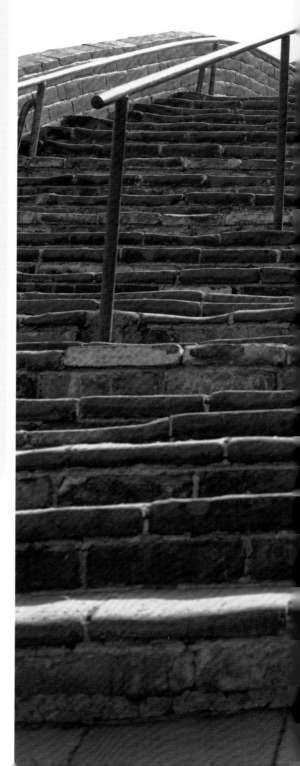

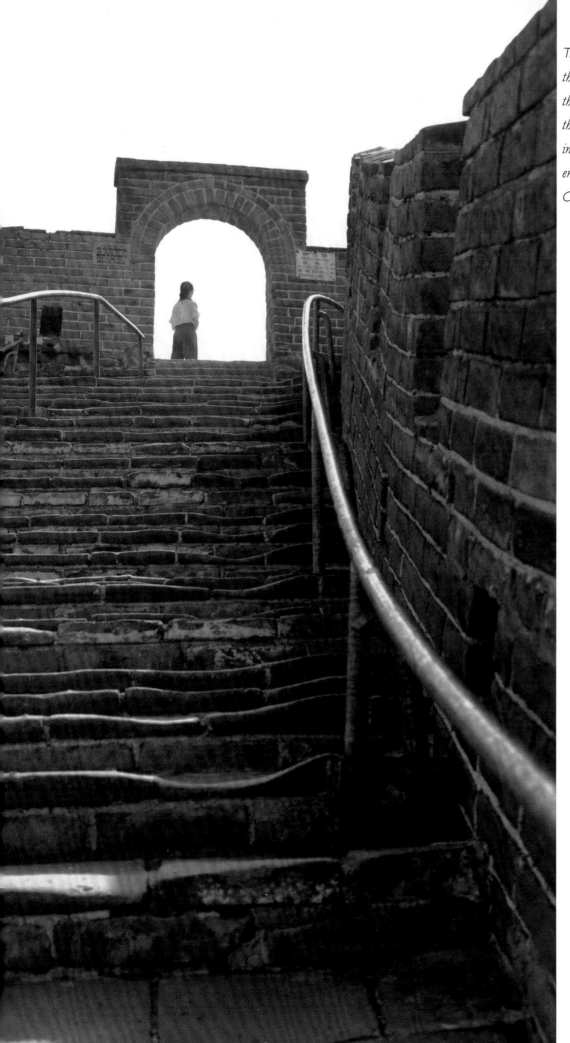

The strong horizontal lines in this shot ground the image, and the secondary curving lines of the handrails lead the viewer into the frame. This is a different and compelling view of China's Great Wall.

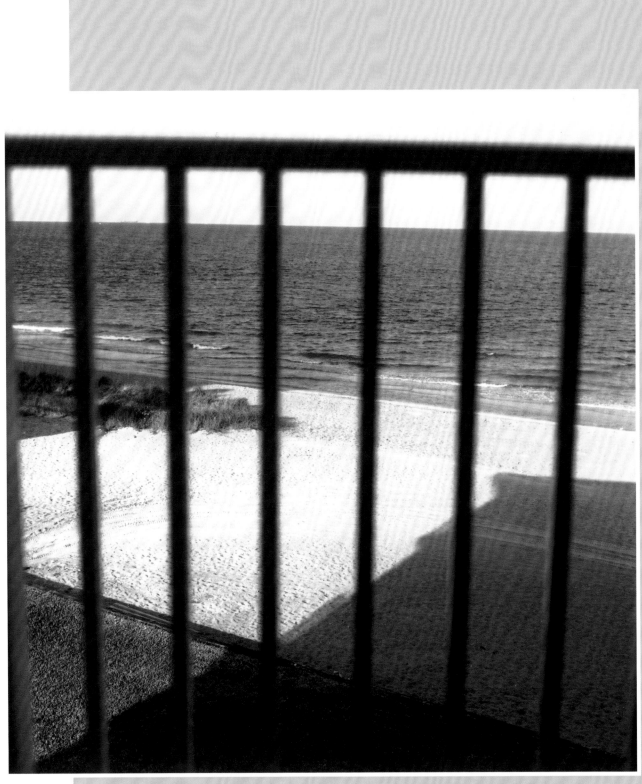

*Mondrian's Beach is a study of straight lines: horizontal, vertical, and diagonal. The top railing of the balcony echoes the horizon line. The building's shadow intersects the vertical lines on a diagonal. This image, although the objects are recognizable, should be considered an abstract.*

# vertical lines

A straight, vertical line implies that all forces are in balance. This is not to be mistaken for the feeling of rest that a horizontal line suggests. It merely denotes the feeling of status quo.

The vertical line is the exact opposite of the horizontal line when it comes to the feeling it imparts. Vertical lines are often found in objects we look up to, or look up at; they indicate stateliness.

Sometimes a picture element presents itself as a line, as in the case of a thin, uniformly colored tree. Sometimes a vertical line is the boundary between two shapes. Sometimes the line is faint; sometimes it is bold. Sometimes we are dealing with a single vertical; often there are multiple vertical lines.

What we learned about variations in horizontal lines applies to their vertical counterparts. However, there is one aspect in which the two differ radically. A horizontal line (especially a horizon line) often runs from border to border; rarely should a vertical enter and/or exit the frame confines. This is not a hard, fast rule (and certainly pattern shots are excluded), but usually a straight-line vertical that enters the bottom of the frame and shoots straight out of the frame's top is to be avoided. Any line that enters and exits an image frame tends to divide the image into multiple segments, thus dividing the

viewer's interest. Also, lines are excellent ways to lead the viewer into the image, but a line that enters and exits the scene will probably cause the observer's eye to follow it instead of lingering, and wandering about in the composition. Naturally, the more noticeable (broad, bold, or pronounced) the line, the more it will act in this detrimental way. Another exception to this suggestion is the picture in which some picture elements are used as a frame (a frame within a frame, if you will). We will detail this type of image framing in Chapter Eight.

Second only to the diagonal line in terms of activity and implied movement, the vertical must be treated carefully. A vertical line, especially one that contrasts with its surroundings, can lead the eye out of the picture. Sometimes it can divide the picture into multiple images. We can do without problems like these. If you are photographing a tree, or trees, you should usually show the trunk(s) coming out of the earth, and if you do not wish to include the treetop, foliage should soften the point where the tree intersects the top of the frame.

Usually a scene containing strong vertical lines works well in a vertical format. We will see how important this type of conformity can be when we discuss shapes in Chapter Six.

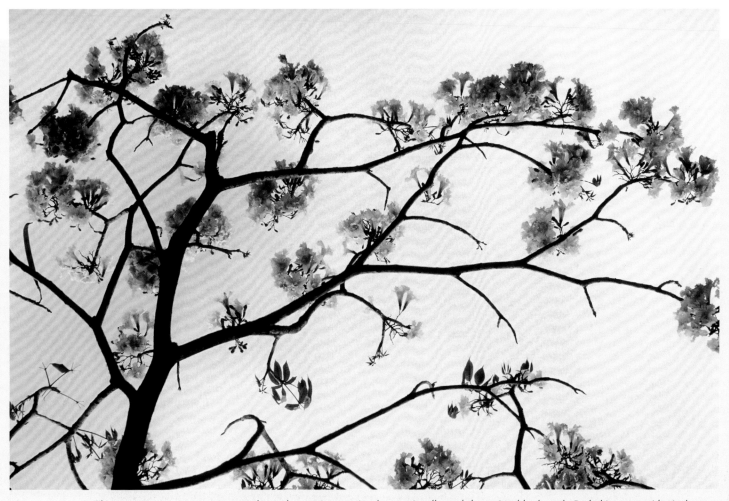

*These are not two separate exposures, but rather one image printed conventionally, and then printed backwards. By looking at two identical compositions we can compare the effect created by an image that forces us to enter the frame from the right as opposed to the otherwise identical image that leads us into the composition from the left. This image speaks to us on at least two levels; a study of a flowering tree, and a composition of rhythm and pattern. How does the difference effect your feeling about each individual rendering?*

## diagonal lines

Diagonal lines are the most powerful and dynamic. They imply movement, often rapid movement. Usually the most exciting images contain strong diagonal lines. And diagonal-line placement is of great importance.

If you learned to read a written page from left to right and top to bottom, a diagonal line entering the print from the upper left will be more dynamic than that same line entering from any other margin. Individuals whose native writings start at the top right of the page, will find

a right-entering diagonal more exciting. In other words, where your eye wants to first enter the picture is of importance, and everyone has not been educated to have the same point of origin.

Naturally, if a strong picture element draws the eye into the picture from another quadrant, it will override other considerations. A bold diagonal line entering the frame at any position will be the object that leads the eye into the picture area.

The most harmonious diagonal is one that rises from the bottom left of the frame. It brings the eye into the frame more slowly than the falling diagonal; therefore, it will cause the viewer to linger longer. If the ascending diagonal does not exit the frame, or if it is greatly diminished in strength (width, and/or contrast) before it leaves the other margin, the desirable effect will be strengthened.

The most important thing that must be known about all diagonal lines is this: diagonal lines should never enter or exit the image area at any corner of the frame. I am a strong believer in the saying, "never say never," but I cannot think of any good exception. Remember we decided that there were no hard, fast compositional rules? This may be the exception.

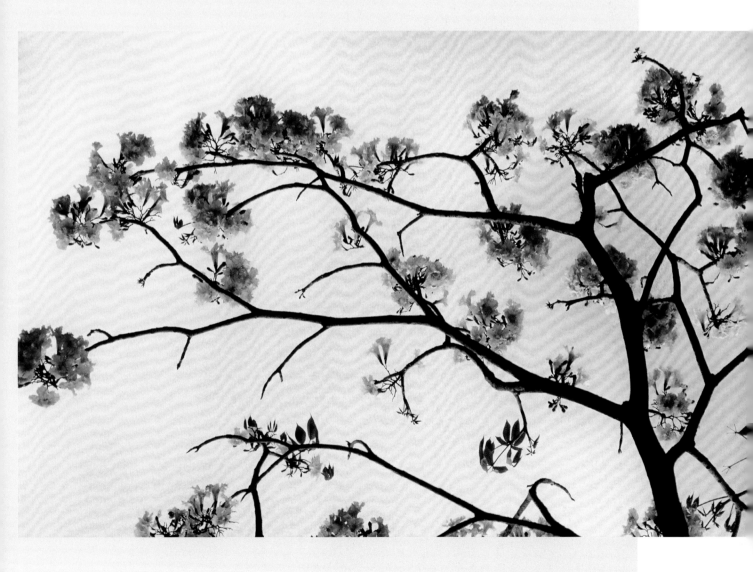

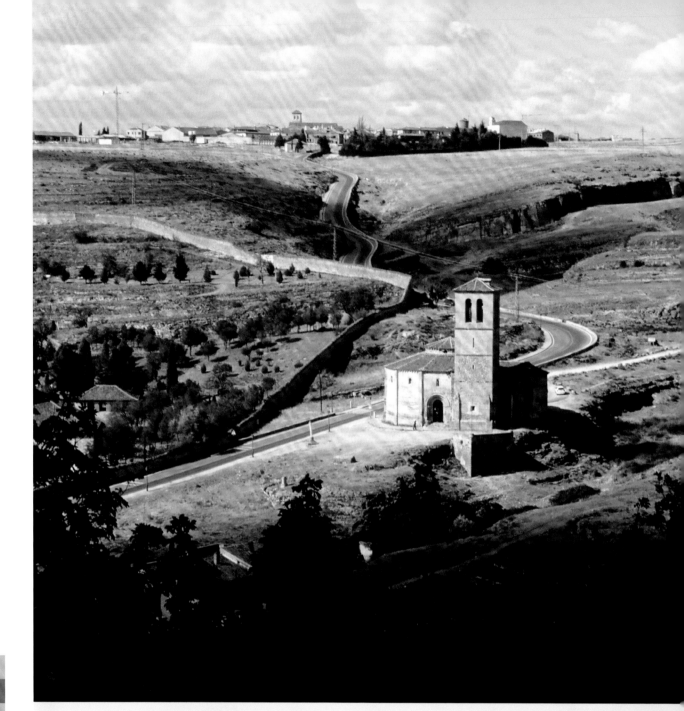

## intersecting lines

The name correctly implies that we are dealing with lines of competing functions. Straight intersecting lines are usually man made. Whoever fabricated the object containing the intersecting lines was the individual who determined the compositional statement of his product. We must correctly decipher the originator's intent, and compose our photograph to echo that mood.

But what do intersecting lines mean in a symbolic sense? They can mean conflict, and this implication is more often true when the intersectors are of equal value. If one is faint and the other bold, naturally the strong one will prevail. We are called on to analyze each line separately; Ockham would approve. Remember that an intersecting horizontal line is still a horizontal line, and a vertical is just a vertical.

*Intersecting lines force us to look at this interesting structure. Not only do the paved and unpaved roads direct us to the center of attention, but even the dark canyon and the cloud's shadow force us to look there. The cloud-darkened trees keep our eye from wandering out of the bottom of the frame, adding to the effect. This scene is in the central area of Spain, an area containing countless photographic possibilities.*

When we can control placement, when all other factors are equal, we can make strong statements by utilizing those wonderful numbers again. Choose either the 5 to 3, or the 8 to 5 ratio. You will like the result.

In the case of intersecting lines (unlike the horizon line), we are selecting a spot, not just a vertical location. This spot depends on the Fibonacci sequence utilization in both the vertical and horizontal planes.

*This ship at anchor is an interesting example of oblique lines. None of the diagonal lines are radically diagonal; all slope in a rather gentle manner, except for the mooring cables. The relative mass of the mooring cables is minimal by comparison to the larger, more contrasty lines of the ship's hull and superstructure; however, they are excellent lead-in lines.*

## oblique lines

Webster's definition of oblique is having a slanting position or direction; neither perpendicular nor horizontal; not level or upright, but inclined. For our purposes we can consider oblique lines as a special category of diagonal lines.

The oblique line is generally more sloping, less radical than other diagonals. It is a wonderful tool when used to lead the eye into the picture, especially when it enters from the bottom, or near the bottom of the frame. Usually, the more the line slopes, the more pleasing is the effect. Some examples of this lead-in oblique are footpaths, roads, rivers, streams, and coastlines.

Oblique lines that converge are our best way of indicating three-dimensional depth on a two-dimensional surface. Used properly, the effect is singular. The almost-horizontal oblique lines offer the best opportunity to display the illusion of depth. Picture a railroad track with two rails that appear to merge into one as they fade into the distance.

Just like other diagonals, they should never enter the frame precisely at the corner. However, if the lead-in is a broad one, like a large river, it may be permissible to have one bank above and the other below the corner of the frame. This is

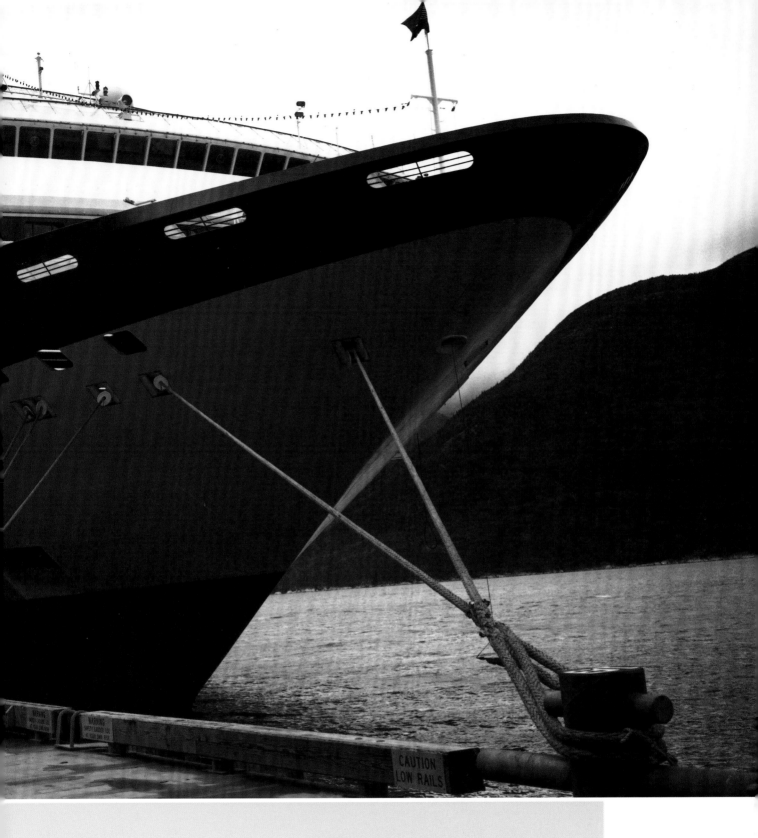

especially true if one of the river boundaries is a more dominant picture element than the other.

It goes without saying that everything we learned about other lines (broad, narrow, bold, faint, etc.) applies to the oblique member of the line family. But, used as a way that causes the eye to enter our personal representation of a composition, it deserves special consideration when we are deciding where to position our camera, before the image is captured.

*The Stove Pipe Wells Sand Dunes of Death Valley are a never-ending source of photographic inspiration. This late afternoon shot illustrates how interesting irregular lines and shapes can be. Photographed at high noon, the dunes produce flat, uninteresting studies, but when the sun is low in the sky, any number of wonders are afforded the prepared photographer.*

## irregular lines

Irregular lines are unconnected segments of the various line types; therefore, most of the above implications apply, within limits. Irregular lines can often be used to set up pattern shots, but used incorrectly they can convey discord. Of course, if discord is the theme of the image, irregular lines will strengthen that aspect of the composition.

Irregular lines that indicate movement in one direction conform to a line-direction theme. It is the irregular lines, moving in unrelated directions, which can cause problems. Irregular lines which point at the subject matter are easier to deal with in a composition because they direct the observer to the point of interest.

## curved lines

So far, we have been discussing lines that are straight, or nearly straight. Now let us consider the most beautiful line, the curved line, and the most pleasing of all curved lines, the S-curve. We will consider curved lines in general first, and then conclude this section with a separate subsection touting the advantages of the S-curve.

A curve generally softens a line and adds beauty whether the line is horizontal, vertical, or diagonal. The smooth movement of this line suggests peaceful, quiet motion. Gently rolling hills are good examples. A meandering stream is usually one that travels in a curved route. The female form is a series of curves.

How we treat curves is our decision, and we have more flexibility in the utilization of curves than we do when positioning straight lines. First, let us consider gently rolling hills. If we photograph them head on (so that we are perpendicular to them), we get the effect of curves running in a horizontal direction. If there are layers of hills receding into the distance, we get a peaceful feeling of depth that is often difficult to convey.

*Taken at Uluru (Ayre's Rock) in Australia, the subtle curves in the rock are contained by the tree's trunk. This is an excellent example of how nature assists the photographer.*

If we photograph curved lines from an oblique angle, we get a somewhat different effect. We still get the peaceful effect, but the feeling of depth is diminished. When a hill, or series of hills, is encountered, exposures from several angles are recommended.

Photographing the hills from a parallel position may cause problems. Locating the precise camera position can be difficult, and the result may easily be diminished undulation. Also, we now stand the chance that each hill will compete with others for dominance. Ockham would be doubtful of this approach. However, if you can pull off a shot that is pleasing under these conditions, you will probably have a unique image.

By now you are hopefully realizing that curved lines can take on some of the attributes of straight lines. Curved horizontals, diagonal curves, etc., react in a dual role. They impart the directional feeling plus the softness of the curve.

Since the beginning of art, the female form has been a popular subject matter. You would think that by now every possibility would have been exhausted, but this is not true. Here is another point that I will make over and over. Study if you will what others have done, but do not try for an exact replication. Emulate the things you like best, but put your own spin on the composition. In this way you have the best of both worlds. You are not reinventing the wheel, and you are not competing.

The S-curve will help you accomplish one of the main goals in image recording. It should always be our intent to cause any viewer to linger long over our masterpiece. A line that wanders slowly through most areas of the scene encourages relaxed, prolonged viewing. The S-curve does this magnificently, and the more of the image area meandered by the curve, the better.

A gently curving line that enters from the bottom, or near the bottom of the frame, will usually convey the effect in the best possible way. Next time you have the opportunity to experiment with this wonderful curve, try introducing it from the left, then right side of the frame. Compare the difference; it is an excellent learning experience.

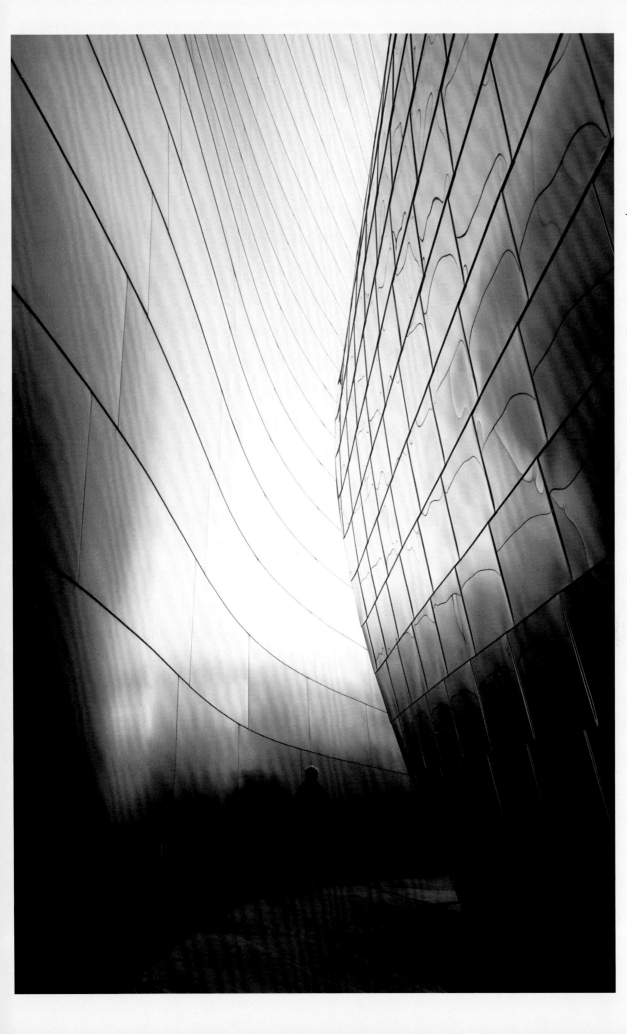

Curving diagonal lines are the key compositional feature of this study. The Walt Disney Concert Hall in Los Angeles, California, offers multiple opportunities for interesting photographs. The figure adds interest and scale to this somewhat mysterious setting. I took other shots, including some that incorporated fill flash. Supplementary light illuminated the scene and the figure, but this moody representation is my favorite.

*This statue of Sir Winston Churchill is a prime example of the psychological line. Its geographical placement is perfect; the sculptor's intent is easy to discern. Often these lines, also called lines of force, exist between human subjects. It is the observant photographer's task to capture images containing these emotional elements. Done properly, the reward will be viewer appreciation.*

## psychological lines

These lines have gone by several names in the past. They have been called invisible lines, lines of motion, and lines of force. Probably having other names, these lines are of great importance to all who wish to execute meaningful, thought provoking images. When two or more

major picture elements are connected by implied lines, a powerful effect is achieved. Usually this requires at least one animate object; often it involves two, sometimes more.

A mother, smiling and staring down at a baby who is grinning and looking up at the woman, is a perfect example of these implied lines. Is this a single line, or a double line of force? I often include a person in my compositions; often it is my ever faithful wife. In a scenic image she is often not the subject, but rather a foil. I position her in a non-Fibonacci position, and have her gaze at the subject. Because she is looking at the center of interest, the viewer is gently influenced to do the same.

The typical, tourist-type picture would have her posed by a significant land-mark, looking into the lens. I take this style of photograph also; it proves we were having a good time. These pictures go in our family album. But serious com-positional concerns would have her lead the eye into the picture. Never have peo-ple looking, or walking, out of the frame. It causes the observer to wonder what is going on elsewhere; when that happens you have lost your audience.

The most interesting of these scenes include local people, doing their thing. But these shots require patience; these strangers must compose themselves to conform, without any direction from the photographer. If you ask them kindly, then try to position them, the image will lose the spark of an uncontrolled compo-sition. It is hard to explain, but the volun-teers will somehow seem stiff and unnat-ural, even if they do not look posed. Also, I strongly believe that one, two, or possi-bly three individuals are all that are needed in this scenario. Too many crowd the scene.

There we have it; lines are of dire impor-tance, and we have covered all the major types of lines. There are other ways we could classify lines, but these are really sub-groups and their meanings can easily be determined by the reader who under-stands the line descriptions above.

A great way to become familiar with the ways that lines can help the quest for better composition is to write down the types of lines and a three or four word description of each. Place that list in your gadget bag, then as you are photograph-ing, try to capture at least one of each. When reviewing your work, see how you feel about the outcome, and the role that the particular line played in the overall scene of the image. These are the build-ing blocks of thoughtful composition.

# shapes

**6**

**ALL YOU NEED TO KNOW:** Shapes, along with lines, are major contributors to the grand theme of any composition. The previous chapter offers clues to the meaning of the geometrical shapes. Yet, there are special aspects unique to these individual shapes; we need to know how to treat them as they are encountered.

## the triangle

When resting on its base, a triangle is one of the most stable shapes. At the same time, any triangle implies movement. If, as in a pyramid, two sides are pointing up, that is the direction of movement. In this case, it can be used as we learn to use converging lines.

A dominant triangle should be considered the focal point of the composition, but special care is required, as this type of triangle can easily create an image that is too static. A faint one will probably be better utilized as a way to entice the viewer's eye into the image.

When triangles are tipped they become increasingly unstable. In any unbalanced position, they take on dynamic qualities that can contribute exciting movement. The more the instability, the more the feeling of implied action and potential energy.

Triangles can also be created when three objects, of nearly equal value, are positioned within the frame. This type of triangle works in a manner similar to lines of force or psychological lines. In this case, they must all be in agreement. That is to say, care must be taken. Three subjects in one composition defeat our purpose; therefore, we must have a strong reason for this style of arrangement. Three individuals, all looking at one subject, will create a strong cohesive force. If they are looking at more than one object, or if even one of them is looking at something outside the frame, the result will be compromised.

*Triangles dominate this Washington, D.C. Metro exit. The strong triangular shapes of the escalator are offset by the cement triangle of the rear wall, then echoed by the incomplete triangle of the sky. Additional small triangles compliment the theme. There is detail in the sky, even beautiful, puffy white clouds; but including them detracted from the three-sided shape theme. The inclusion of the tree tops somewhat softens, and adds comfort to this otherwise Orwellian landscape. Also notice how the one opposing figure balances the composition; and remember, we decided that three figures (or three of anything) were better than two. Thank you, Mr. Fibonacci.*

# the circle

The circle is a wonderful object to photograph. It is the symbol of eternity, completeness, and perfection. Once, when applying for a commission, Michelangelo proved his ability by drawing a perfect circle freehand. As the story goes, this feat was sufficient; he got the assignment.

There are many ways to photograph a circular object. However, care must be taken not to cause the completeness of this shape to quickly lose the viewer's attention. If the eye is permitted to circumnavigate the object in an uninterrupted sweep, interest quickly shifts elsewhere. The image has lost all hope of being effective. Stated another way, if the top is identical to the bottom and each of the two sides, completeness becomes monotony.

The obvious solution is to break up the circle in some manner. One good solution is to arrange the composition so that some object covers a portion of its circumference. Another excellent way to create interest is to design the image so that part of the circle extends beyond the boundaries. Each situation is different, and sometimes we do not have full control. When we can obscure part of a circle's face, as in a tabletop arrangement, we have ultimate discretion. In the field,

camera position and/or control of perspective are our best hopes. As always, if several possibilities exist, experiment with them all.

Even when photographing an object that is not a perfect circle, these guidelines should be considered. Is an entire apple what we want to photograph, or is it more appealing when a bite is missing? Should a whole head of lettuce be our stand-alone subject, or should other related objects be included? While we are on the subject of food, let us consider plates. Plates, like other circular objects, are usually rendered in a more pleasing manner when they are photographed from an oblique angle. Even if the dish contains edibles, we are most satisfied when a composition of this type is portrayed from the same approximate angle that we are accustomed to seeing when we are at table.

An interesting self-assignment would be a series of images that all contain circles: round shapes that appear as ellipses due to camera angle, circles with other objects, circles that are partially obscured, circles made interesting by highlights in some areas with shading in others, and the numberless variations available to the inventive photographer.

*This image both demonstrates a different way to address the capture of a circle, or many circles. Photographed in its entirety and flat on, a circle can be a boring and uninteresting object. This image was shot outside a garden in South Korea and depicts multiple circles, but shot at an oblique angle, each circular pot bottom is ovular in appearance. The various deviations from the round are of some interest in this image.*

# the square

The square shares some characteristics with the circle, because both are symmetrical. It is also a stable form, difficult to topple, firmly seated and static. The guides we learned about photographing circles certainly apply to the recording of squares. Having biaxial symmetry, the square is tensionless. If we wish to convey a feeling of permanence and/or power, the square is one shape to consider. The stability and restfulness of a square can be additional reasons to photograph square objects, but these attributes closely border dullness. Be careful not to cross that fine line.

Perfect squares are rarely encountered in nature; they are typically man-made objects. Sometimes they were employed for their utilitarian function; skillful designers combined efficiency and aesthetics. Beauty is in the eye of the photographer who senses an art form in the mundane. Buildings are rarely square, but their windows often are. Sometimes multiple squares are used to break up an otherwise uninteresting façade. As image capturers, we have the opportunity to observe what others have constructed, and the option to capture that which entices the finger to the shutter release button.

When planning a composition, be observant of all factors. Be especially careful of objects, like the square, that can create monotonous repetition. If you include them in your image, look for ways to side-step tedium. If you solve pitfalls creatively, the result is likely to be a unique image, one that satisfies and intrigues the viewer.

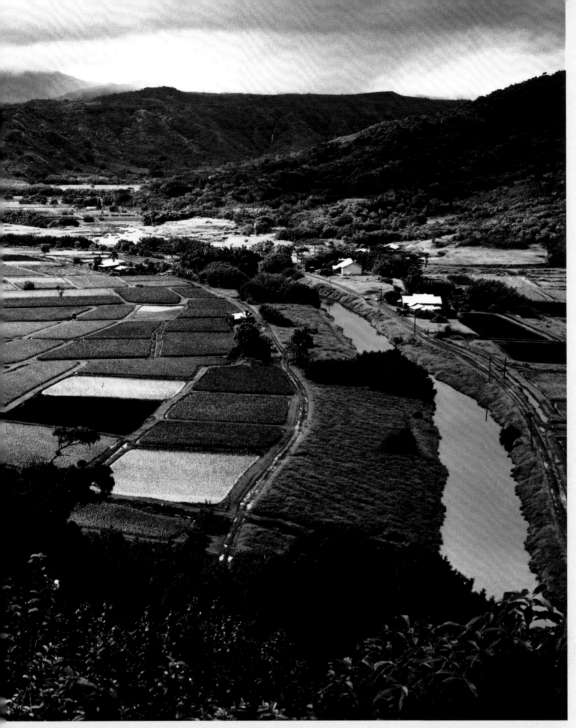

The square is almost always a manmade shape. Photographed head-on, it presents many challenges, monotony is probably the most prevalent. However, many square shaped objects can be exciting, or at least interesting. Mondrian paintings are wonderful examples of properly utilized squares. These squares are a tribute to the farmers of the Hanalei Valley. Located in the northern part of Kauai, Hawaii, they are a pleasure to view. The oblique rendition of squares, rectangles, and other similar shapes illustrate the blending of civilization and nature. If an image of just the planted areas were compared to this shot, it would lose the flavor.

# the rectangle

At first glance, we see the relation between the rectangle and the square, However, when considered as forms to photograph, they are worlds apart. The vertical rectangle may be stately while the horizontal is usually restful. The square is neutral. We are most fortunate when a rectangular object in the photograph echoes the rectangular shape of our frame.

The rectangle is the most commonly used geometrical shape. It is an important building shape, for more than just photographic composition. Everyday objects like writing paper, plywood sheets, and bed coverings are examples. Architecture and landscape planning always utilize the rectangle in some form or another. As photographers, we find ourselves relying on the rectangle as our most important shape. Now we see this occurs as the frame, and in the frame.

In any shape, the longer dimension is the one that governs psychological meaning. We learned, in the study of lines, what these implications are. Also, we discovered that a tipped triangle suggests motion; rectangles can also impart the same feeling when they are placed similarly. Rectangular formats are easiest to compose, and rectangular objects in

the composition conform, while generating countless possibilities. When recording format, image format, and subject format are all in agreement, the image-capturing process is simplified. How could anything be better? What if all three coincided with the Fibonacci sequence?

*You can easily see the stateliness implied by the repetition of vertical rectangles in this scene. The vertical rectangular frame of the image emphasizes this feeling because the format and the subject are in agreement.*

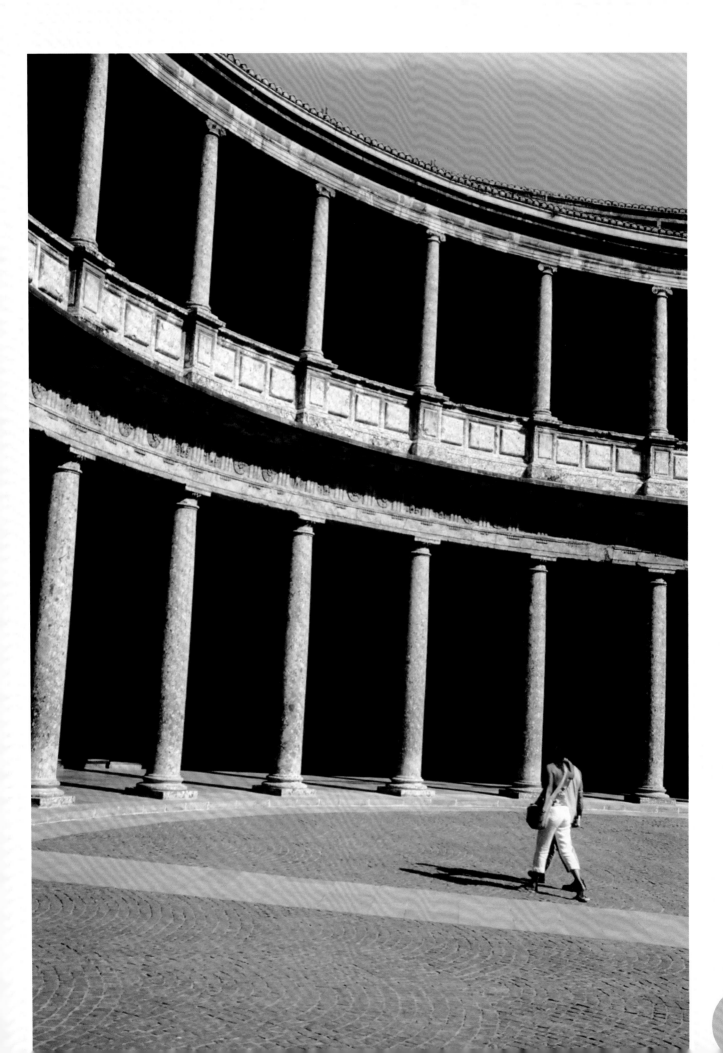

# irregular shapes

Dealing with ambiguous shapes offers the opportunity for more freedom, but less guidance. When dealing with irregular objects, we will find that no two are exactly identical. It will be more difficult to treat each new challenge as a repetition of some previous compositional encounter. Therein exists the opportunity to be creative.

Geometrical shapes are usually man made. Irregular shapes are commonly found in nature. When irregular shapes are found on constructed objects, usually nature played some part in creating the effect. Some natural examples are clouds, tree bark, rock-lined seascapes, and animate figures. Weathered, cracked, and peeling paint typifies the combination of civilization and natural elements.

What do we do when we encounter these asymmetrical, ambiguous forms? First, study the entire expanse carefully to determine what caught your fancy. Will the image reveal a pattern? Does it contain rhythm? If so, how can we maximize the effect? These types of images are dependent upon proper lighting; when is the opportune time to capture the best light? When shooting close-ups, often daylight shots can be improved when off-camera electronic flash is employed, because texture and pattern are usually best portrayed when cross lighting amplifies the texture. The photographer who always carries a remote flash unit is prepared for this scenario.

If the scene does not fit any descriptions mentioned above, analyze the scene in a different way. Can any knowledge we gained pertaining to regular lines or other shapes be applied here? Individuals viewing a composition will inadvertently create connections, if given the chance. Our job is to ease that process along. Can dissimilar objects create recognizable forms? Can like forms be connected via lines of force? By disassembling a complex problem and studying the components, we simplify our task. The razor works here also.

*The slot canyons of Arizona offer never-ending opportunities to the photographer. They yield prime examples of irregular shapes and awesome colors not normally found in rock formations. When their multiple, yet irregular, contours exhibit some pattern, the viewer's eye is pleasantly rewarded.*

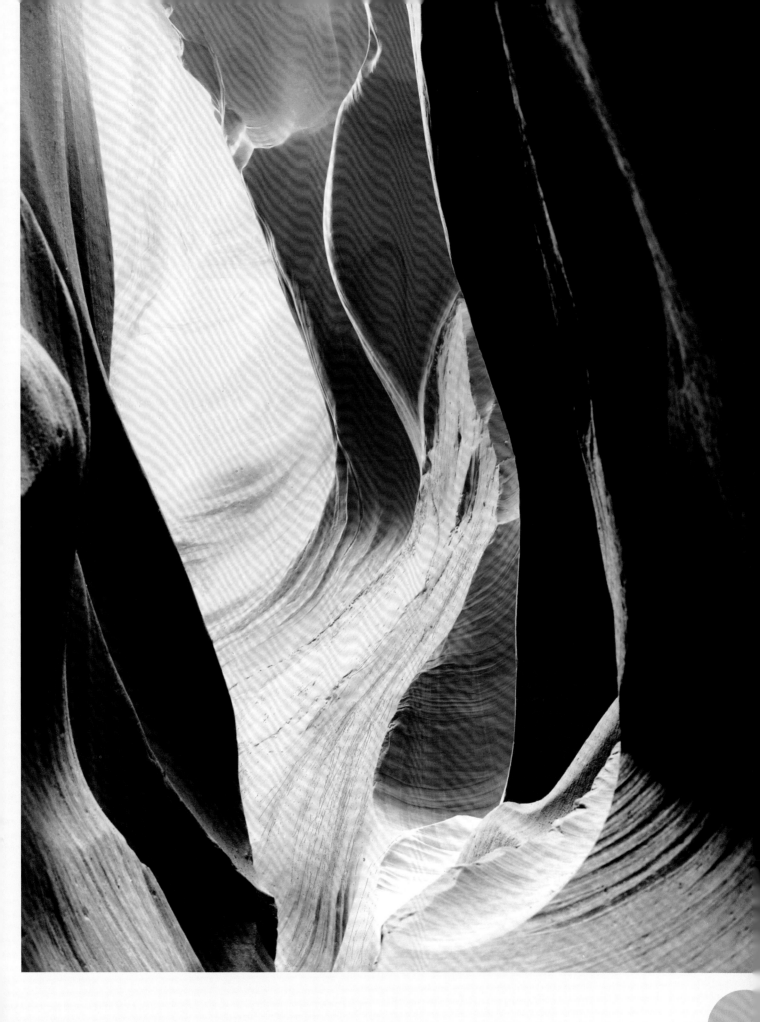

# subject placement

7

**ALL YOU NEED TO KNOW**: Some simple guides will most often solve image-placement issues. We must arrange our composition so that all the elements are treated in the best possible way. However, first consideration must be given to the primary subject. Secondary objects of interest should be given consideration next.

Sometimes it is important to show the relation between the subject and its environment, but the usual pitfall (especially with beginners, or tourists who are enamored with an exotic location), is to include too much local atmosphere. Did you put the razor away yet?

So we decided to move in closer, because we discovered that less often says more, but now what? Let's find out several ways to solve the subject-placement dilemma.

## the rule of thirds

Most people who have studied elementary composition have learned to place the center of interest by using the rule of thirds. This rule would have you divide the picture area into nine smaller equal rectangles; therefore, you would have three ascending from bottom to top of the frame. You would also have three divisions dividing the frame horizontally. This segmentation offers four points that are one-third of the distance into the center of the enclosure. Subject placement at any one of these spots will produce a pleasing arrangement.

We have previously learned that the subject should have some relationship with its surroundings, thus enticing the viewer to linger. We are competing for viewer time; this is accomplished by creating context interest. If the subject is an animate object, and that entity is looking, or heading outside our image area, we are implying that there is something more interesting elsewhere. Either scenario detracts from cohesiveness.

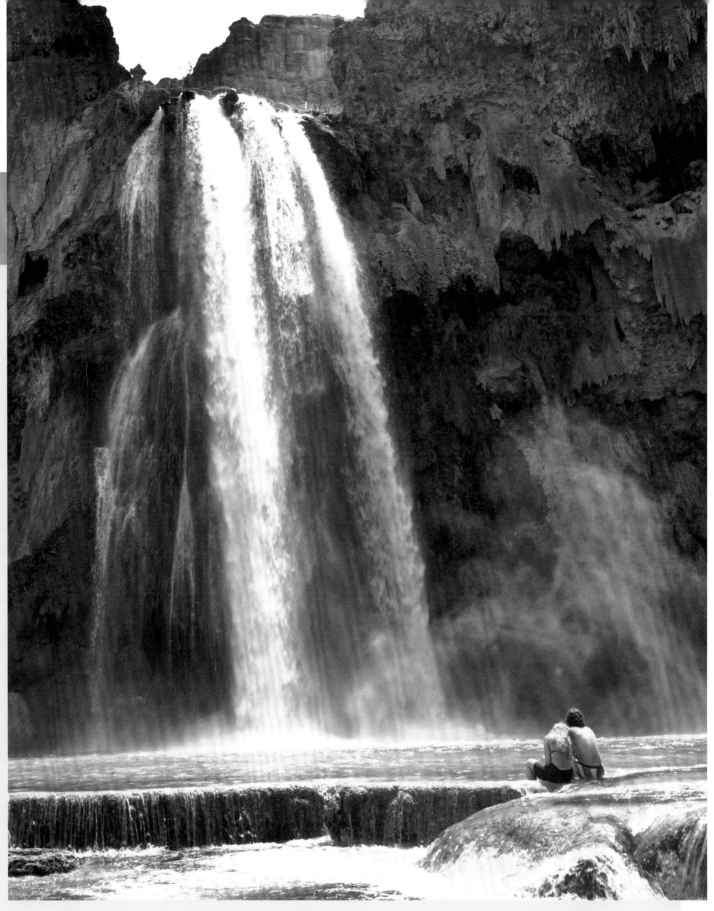

*This image of the Havasupi Falls show us how important image placement really is. The two lovers in the lower right-hand corner of the print tie elements together, indicate scale, and inform us that the falls, not themselves, are the dominant interest in this unique image. It is unique because this precise scene will never be repeated. Therefore, the tardy image-maker would have captured another later, possibly less interesting arrangement. The Boy Scout motto pertains to photographers as well.*

## the fibonacci numbers revisited

A single subject should rarely be centered in the frame. The photographer must use her own discretion when it comes to exact subject placement especially when shooting a portrait. In this case, the left-to-right placement may fall one-third into the composition, but the top to bottom placement is dependent on other factors. There must be a comfortable amount of space above the head, however, too much headspace creates the feeling that the subject is falling out of the picture.

While we are on the subject of portraits, a slight digression from the rule of thirds is in order. A group study should also follow the guidelines mentioned above. Naturally, every head in a group cannot be placed at the same elevation, and even if that were possible it would probably create boredom. Determine who is the most important person in the group, and give him/her the place of importance. If there are multiple objects of interest (a family, a cohesive group, a team, or even a combination of humans and animals) the focus of their attention should be in agreement.

As we discovered earlier, the photographer must have control over subject placement, and if there is urgency, shoot quickly or lose it. The rule of thirds may be the answer. If the best possible placement is our desire, there is a more sophisticated solution.

As we learned earlier, we should be dividing our working area into golden mean sections. We discovered that a pleasing division is either 3 to 5 or 5 to 8. In actuality, both ratios will place the divisions in approximately the same positions, but the five-to-eight combination is a fine-tuning of the sequence theme. If we divide image area in this proportion, instead of into thirds, the overall result of the composition will improve.

You knew that was coming, didn't you? And I anticipate your next question; how can you possibly divide the camera's frame into these divisions? Well, two groups of photographers will have little trouble accomplishing this task. Some of the better digital single-lens-reflex (D-SLR) cameras have removable focusing screens. They can be replaced with so-called architectural screens. These screens are segmented by fine lines that were designed as an aide in aligning vertical and/or horizontal lines in man-made structures. These lines are also wonderful image design devices. Photographers have been known to purchase extra focusing screens so they can be marked, with an extremely fine marking device. I do not recommend marking the only focusing screen in your possession. Keep the original one pristine so the camera can be returned to its original configuration. Owners of cameras larger than

35mm have an easier time customizing screens, because as camera size increases, so does screen size. There is also the possibility to customize the finder screen with a properly marked, thin transparent overlay.

The digital photographer can easily indicate golden section lines on his LCD screen. Again, I dislike defacing the camera, but many screen protective covers are available as accessories, and they are quite inexpensive. Obtain transparent ones and customize them. If none can be purchased, virtually any transparent material can be used. They can be attached in many nonpermanent ways, including Velcro™ or rubber bands. These learning devices may eventually be removed, because at some time, correct subject placement will become second nature.

Serious compositional studies will be greatly improved if the subject arrangement is observed carefully. To accomplish this study, a tripod is essential. A stationary viewfinder, ground glass, or LCD screen facilitates careful image scrutiny. When you are observing this image, the first thing you should look at is the subject, but then observe the remaining picture area carefully. How much can be excluded while still getting your point across? Next, carefully scrutinize the entire frame area for any unwanted elements that can distract from the theme.

*The Alhambra in Granada, Spain, is one of the most visited and photographed spots on earth. When traveling to places that have been overly photographed, it is difficult to generate a unique image. Hopefully we can come away with at least one image others have not seen. What is this lonely figure thinking? Does it matter? Without his presence this study would have lost most of its impact.*

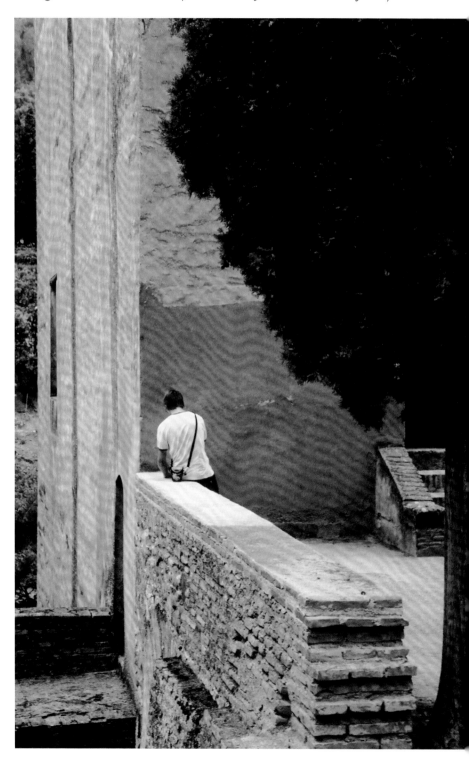

Hand-held shots are necessary some-times, but at all other times, a rock-steady image preview will afford the best opportunity to compose most precisely, and usually the picture will gain in overall sharpness if a tripod and cable release are used.

We are not primarily concerned with pic-ture-taking techniques in this study, but please take note of one fact: numerous studies have proven that, even at higher shutter speeds, few photographers can obtain the maximum sharpness from hand-held cameras. This is something you can easily prove for yourself. Take two shots of a still object, one with a tripod and one hand-held. Enlarge them until the hand-held shot starts to show the tell-tale signs of softness. Now blow up the tripod-captured image. Are you convinced?

Since the image placement divisions and the horizon positioning guides fall at the same golden positions, the examples for both have been seen in Chapter Five. Now that we have seen how the Fibonacci Numbers help us construct a strong composition, and how really easy it is to adhere to that principal, is there any reason to choose any other image component placement system?

We have already decided that there are four optimum places for our subject, we need to consider the fact that all of these points do not share equal importance. It is necessary to understand their exact pecking order, and have a firm knowledge of how this type of placement affects our composition.

We use terms like "look up to" indicating that something, or someone, is held in esteem. When we position objects in a grouping, the ones that are positioned above the others are said to be in a position of honor. This is also true of subject matter in a picture. For conformation of this statement, look at any old masters images.

So now we see that important subjects should be positioned in the top portion of our frame. Let us also consider the differ-ence between the left and right golden point. We discovered that the eye enters a picture area in the same way that it was schooled to read a printed page, so the left quadrant is the first thing we would notice, all other factors being equal. Therefore, placing our subject there will cause the viewer to study it before observing any other components of the scene. This may be desirable, but it may not be the best choice. Experimentation is the best teacher.

If the subject is placed in the upper-right magic spot, the viewer's reaction is to enter from the left of the image, then scan to the right. So if the subject is there, it effectively stops the eye scan from exiting the frame,

*This illustrates the ideal proportions of a horizontal print, and the optimum positions in which to place our subject for maximum effectiveness. The bold lines intersect at a point labeled "1." That spot commands the most importance. But sometimes a scene precludes positioning a subject in position 1. The next best choice is position "2." Placing an object low in the composition indicates that it is of lesser importance. An object in position "3" is probably a complementary device that adds cohesiveness to the overall composition. An object placed at the number "4" spot demans less attention than objects in any of the other three, but can often be an effective way of redirecting the viewer's attention back into the image area.*

thus creating a more pleasing, possibly exciting image treatment. If the dominant object of interest is placed there, it must be composed, posed, or placed so that the viewer's only choice is to secondarily observe the additional image components. Here we have another self-teaching opportunity: when given the chance, take two shots (left then right subject placement), and see how this affects the feeling of your end product. Please make prints to study. An LCD image, because it is smaller than the end result, may not be effective in revealing some of the subtle differences. Side-by-side comparisons are easier to study than flipping back-and-forth on a screen.

Side-by-side comparisons can also illustrate the value of objects that inhabit the lower quadrants of the image. If an object is positioned in the lower portion of the frame we are telling our viewer that it is of lesser importance. It is probably just a component of the major theme. A small human figure placed there is often used as a lead-in, and to indicate scale. I believe that a scenic is more interesting when it is inhabited. Any or all of the above are excellent reasons to consider including the human form in pictorial images. The figure may be tiny; in fact, if the figure is too large, it may detract from the overall effect. If you learn by studying comparison images, try variations on this theme; it will be rewarding.

# precise image placement

Now that we know the four golden positions, and realize that some are more important than others, it becomes easy to sort out the way we compose any scene. Let us consider why this formula does not always work.

When composing a scene without one strong object of interest (take, for instance, a meandering stream that wanders through a meadow with snow capped peaks in the background), it would be advisable to have the stream become the lead-in. Remember, we decided earlier not to have it enter the picture from the exact corner of the frame. Now we surmise that this lead-in should, at some point, intersect at least one of the golden points. A boat, or some other object of interest placed there would be beneficial.

We also said earlier that if all things were equal, we would start viewing the print from the upper left, because that is how we were taught to read. In the scene described above, a new factor comes into play; we would view the image as a person walking into the scene. We would enter from the leading line, and follow where it takes us. If the leading line is a path, the viewer is compelled to imagine what it would be like strolling along that trail.

If there is no leading line or if the line is a path, a small human figure placed near a logical entry point would greatly enhance the composition. Lead-ins are important; look for them. Often a slight change in camera position will open up the scene and make it more inviting. Under no condition should a viewer be barred from entering the scene. A fence, no matter how interesting in itself, should never run completely across the bottom of the picture area; fences say, "keep out." In such a scene, use an open gate; invite your viewer into the composition. The exception would be a scene that depicts a hostile environment, prison walls or devices designed to keep people confined or restricted.

Even the staunch proponents of the golden segment deviated from it, as needed. It is a powerful guide, but it is not apropos in all instances. There are several learning approaches that one can take. For example, shoot only simple, existing compositions that do apply, set up shots that fit the formula, or try to fit existing scenes into the mold. In the last scenario, if the composition seems strained, experiment with subject or camera-placement deviation. I hope you agree; the simple approach is the best first-line of discovery.

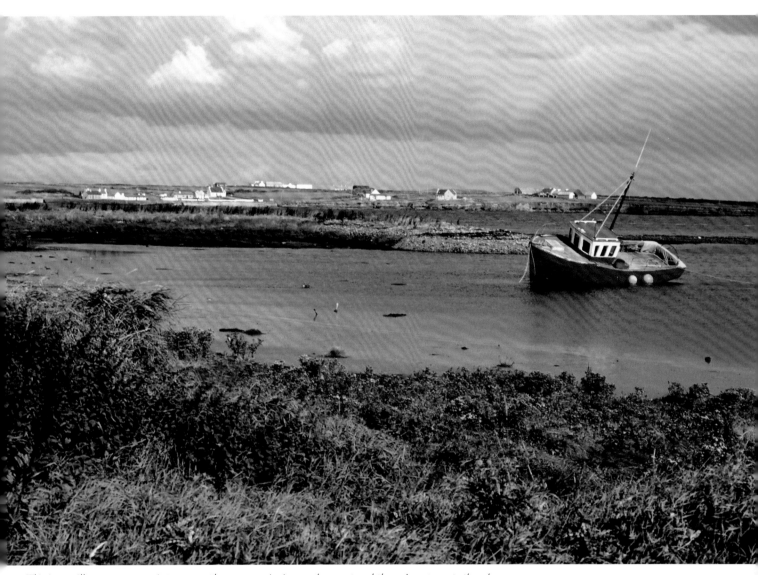

This image illustrates many points; among them are precise image placement and the eye's response to the color red. If your eye enters the frame from the left side, it is stopped from exiting by the placement of the boat. If you immediately were drawn to the image of the red boat, your eye was directed back into the frame, because the boat points you in that direction. A strong image will cause the viewer to linger and enjoy the view. This typical Irish seascape is enhanced by its simplicity.

# balance and unity in a composition

**8**

**ALL YOU NEED TO KNOW:** Your construction should be a pleasing unity. Think of houses that you like. They are well designed, with proportions that are logical, the components (doors, windows, trim, etc.) conform, and they fit into their environment. Contrast that with the older house that suffered a poorly executed add-on. Keep this analogy in mind when composing an image. Now let us consider the components that will help us build our pleasing unit.

## framing

A frame, within the image, helps create unity and focus. It should be darker than the area it contains, thus further concentrating the attention of the observer. Sometimes the frame itself can be an interesting part of the composition. A frame can also create a comfortable position for the viewer while he or she observes our scene. As in the picket

fence scenario from the last chapter, the frame should not restrict the viewer from entering the scene. By that I mean that the viewer's attention should be confined to top, left, and right, but the bottom should allow easy access. There is much that could be said about framing a scene, but I believe it is more instructive to look at several examples, and see how they enhance an otherwise mundane image.

Before we do that, let me offer a word of warning about light traps. A light trap is an extremely bright area surrounded by a darker one. A good example of a frame containing these traps is encountered when using trees as a frame. Spots of brilliant sky blazing through a darker, leaf-generated frame cause the unpleasant trap. Light traps will be discussed in Chapter Eleven. For now, just know that they are to be avoided.

*Framing a shot often adds the extra dimension that propels the image to some higher level than an unframed version commands. Castles in Ireland are more plentiful than stop signs in California. Each one is a photo op, but we need to be creative if we wish to separate our offering from the pack.*

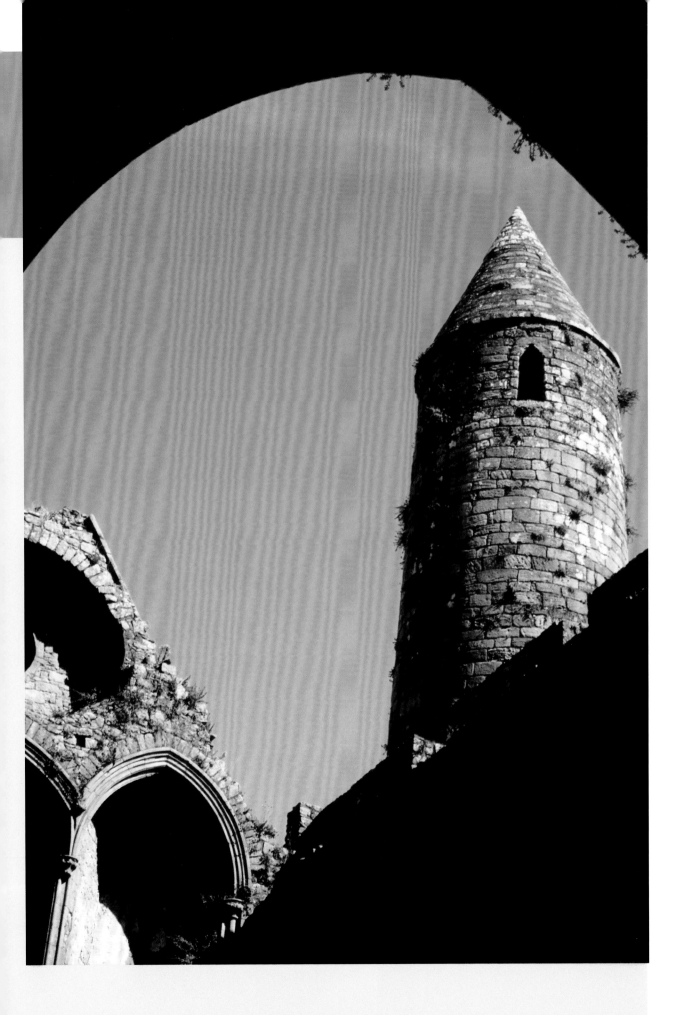

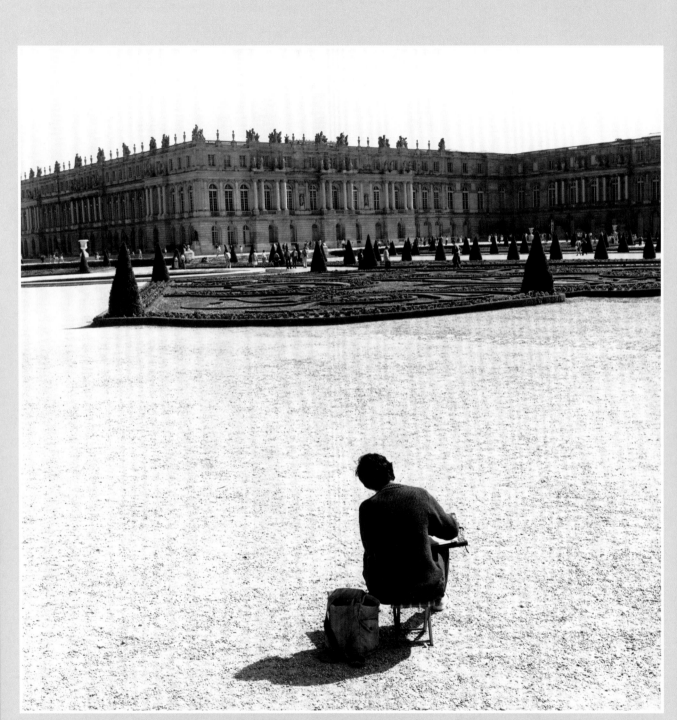

*This shot at Versailles Palace in France beautifully illustrates how space within the frame supports the entire composition. Without the space to separate the figure in the foreground from the complex background, the image would lose its punch and appear too cluttered.*

# space

Proper utilization of space is a nebulous, varying proposition. If the image is meant to convey an open feeling, more space is required, and yet wasted space can be detrimental. Usually, the best solution is to use as little open expanse as possible.

If the image is of a beautiful landscape, and the clouds are simply marvelous, first inclination would be to show all the wispy variations that you captured. If the principal thrust of the composition is to showcase clouds, as in a magnificent sunset, then include the interesting ones. If the reason for the image's existence is in the foreground, the Ockham razor should be utilized.

Here is a helpful learning project. Shoot two shots of a scene like the one described above. One should be an all-inclusive composition, and the other a tightly cropped image. Compare them. Then make a cropping tool by producing two pieces of cardboard, both in the shape of an "L." Make them large enough to exceed the length and width of any print on which you wish to practice this cropping technique. They need not be fancy, but you will use them over and over as you learn.

They are used in this way: one cropping tool covers the top and the left side, while the other covers the bottom and the right of the print. You can slide them diagonally to crop two print edges, or move in only one direction, thus cropping from one border at a time. Of course, a cropping tool is not absolutely necessary; four white pieces of paper will accomplish the same task. You merely move one at a time.

Now make a hard-copy print of the all-inclusive composition. Move the cropping devices; crop from the top, then the bottom, and then from both sides. While learning, it is better to crop from one print edge at a time. Even if you are satisfied with one area of the print, try cropping it anyway; you may be surprised at what you see.

You should crop with brutality. Keep only one thing in mind. You want the simplest, least cluttered image possible. Remember, the strongest image may not fit into the confines of a factory-determined paper format. Prints may be trimmed, or borders customized to conform.

After you have seen the most pleasing composition possible from the cropped image (using the cropping tools), how does it compare with the tightly cropped image you originally shot? If they are the same, you are well on your way to photographic seeing. If the subsequently cropped image is better than the original, what does that teach you?

So far we have considered one aspect of space, the obvious one, but what about the illusion of space, the so-called pictorial space? We usually want our

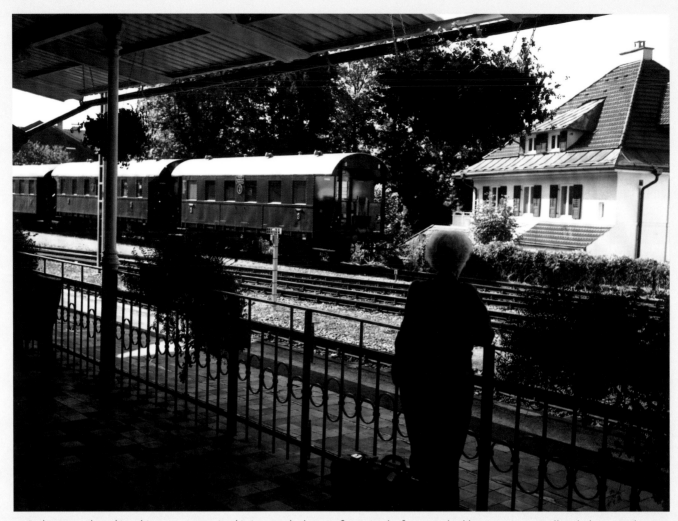

*Balance can be achieved in many ways. In this image, the human figure in the foreground adds continuity as well as balance. Is she waiting for someone to arrive, or is she departing? Either way, her physical shape is enough to balance the scene. Balance is not dependent upon the offset of equal objects. The human figure carries enough importance to stabilize an otherwise unbalanced composition.*

## balance

two-dimensional image to convey a feeling of depth, and/or expanse. Conversely, we may wish to compress space to indicate a closer relationship to two or more objects depicted. We can become magicians and utilize smoke and mirrors. As photographers, our tools of the trade are the use of lines (see Chapter Five), the handling of foreground and background (following shortly), and perspective (see Chapter Ten). We see that many individual aspects of composition are closely related, more closely than we originally thought.

Balance is achieved by the careful distribution of shapes within the frame. A heavy-appearing object on one side must be offset by similar weight on the other side. Inside our illusion we are concerned with apparent, not actual, weight. Properly placed, a small foreground building may offset a large mountain in the distant background.

A grouping of several smaller objects on one side may perfectly balance one large one on the other side, if placed correctly. Darker objects appear to have more weight, so balance may be achieved by the juxtaposition of tone and/or color. If multiple objects, known to be of identical weight, are at various points, the closest (therefore the largest), will appear to be the heaviest.

Top-to-bottom balance is important also, but usually nature has taken care of that for us. In man-made structures, designers have followed suit. Only rarely do we have instances where the top-half of our frame seems heavier than the bottom. In instances of this sort, include a minimum of the darkness at the top of the composition, and offset with balancing foreground.

A unique object, possibly a person, carries more pictorial weight than the mundane; therefore, that object can be quite small, yet require a larger object to achieve balance. Remember our earlier example of a mother and child, looking at one another while smiling? This could be a well-balanced image.

A good image requires balance, regardless of how it is achieved. A weighty object on one side of the picture must be offset, or the image will seem to tip. Fortunately, once we become aware of compositional balance, it is readily seen, and most photographers instinctively create well-balanced images.

*Is it usually easier to compose a single subject than it is to cope with multiple ones. When multiples occur, odd numbers are preferable to an even number grouping. Here is an image that features three bells that were artfully positioned by an architect who followed this same principle. Leonardo Fibonacci would concur.*

99

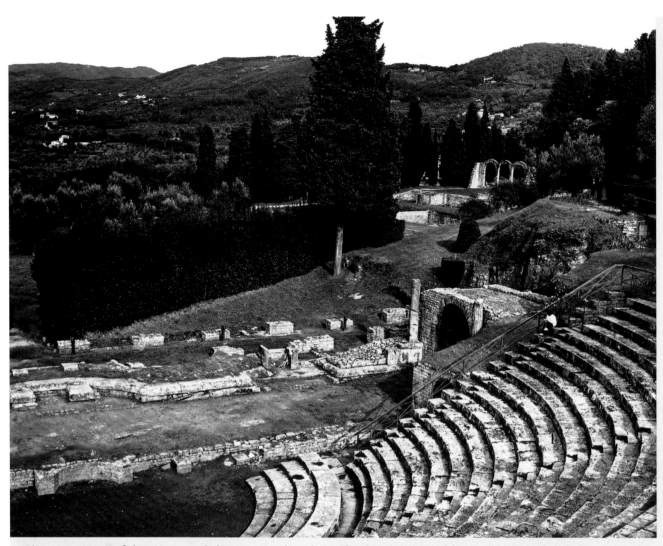

*This representation of the ancient amphitheatre in Fiesole, Italy, typifies the relationship of foreground and background. The prime source of interest lies in the foreground structure, and scale is added by the sole figure. Her white blouse adds to the ability to discover her, and in this way appreciate the human element, regardless of the small portion of the image she occupies. But now notice how the ruins of the theatre harmonize with its surroundings. Any trace of a modern structure, anywhere in this composition, would have destroyed the mood.*

## foreground

The foreground is where most of the picture's interest is usually concentrated. Careful consideration and critical scrutiny of the foreground certainly aid in the production of the overall effect. Before we place our subject in a proposed scene, we must be certain the scene is set.

We have already learned to scan the area for previously unnoticed trash cans. Now let us look for light or bright colored objects, those that are unrelated to our theme. Ideally, our main subject should be the lightest and/or brightest object in the scene. We will see this graphically in Chapter Eleven.

Another wonderful attribute of a great scene is one in which the immediate foreground is darker than the middle print area. This too, holds the eye where we want it to be. If the bottom-print area

# background

gradually lightens in such a subtle way that the viewer is unaware we are controlling his viewing process, we have created a very good illusion. When this is impossible in the field, post-processing with an image manipulation program on the computer is in order.

In some scenes we will have foreground, middle areas, and background. Other times we may have just foreground and background. The middle portion and background planes may contain important details, little detail, or none at all. This is often controllable; sometimes camera positioning will make a big difference. For example, a shot made from inches above the ground could possibly eliminate all but foreground and sky. That same shot from atop a ladder would introduce some middle ground.

The above scenario is a way of decreasing, or increasing pictorial space. We can use diminishing planes, when available paired with foreground planes that are sharp, contrasty, and detail filled. Then with each receding plane, detail and brilliance diminishes. This is one of the finest examples of implied space on a two-dimensional surface. Conversely, a flower photograph showing just the earth at its base, and blue sky behind it, offers no illusion of depth. In this instance that is probably the effect we desire.

The background is an important element of any photograph. An excellent one complements the idea we are trying to convey. In other words, it is in complete agreement with the subject, and in no way detracts, or causes the viewer's attention to wander. In some instances it may be completely neutral, so much so that the person observing our image is unaware that a background exists.

In the field, we often have little control over the background. A shift in camera position may be all that we can expect. We need to capture the subject in the

*Harmony is achieved in a photograph when all elements are in agreement. This Venice canal scene is an excellent example of that effect. Everyone has seen images of the famous Venetian canals; individuals who have ridden them remember them fondly. In a well-loved environment, all the components of an image must be in accord, or the magic dissipates. Notice that in this image, we have balance, scale, psychological lines, plus foreground and background agreement.*

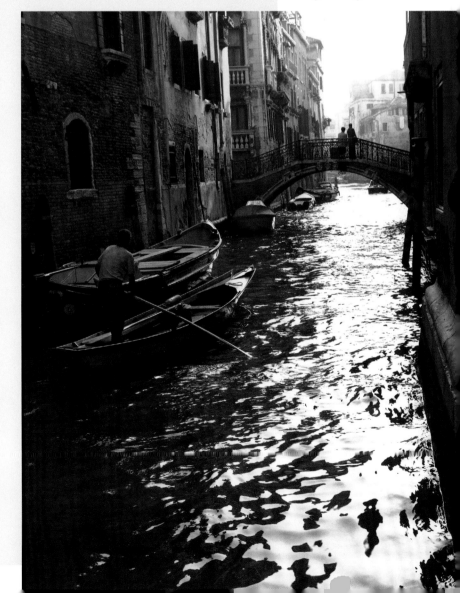

correct light, so we probably cannot move left or right more than a limited number of degrees. Sometimes we can shoot from a lower, or higher angle, as described above, but in most cases the amount of up or down movement is limited by prevailing conditions.

Sometimes, you can hide a distracting background element by positioning the camera so that the objectionable component is behind the subject. How we overcome a challenge of this type is an ever-changing exercise, a photographic mind-over-matter puzzle. The first and most important step is awareness that a problem exists.

If the problem cannot be eliminated, the answer may be to make a record shot, and then think about the future solution. Studying a failed shot is good preparation for a repeated attempt and/or similar encounters. If we know that a problem exists before the exposure is made, we are a long way towards compositional-problem solving. So if the poor result is anticipated, we have gained from an advanced learning experience.

When shooting indoors, we must control our backgrounds. Formal portraits present no background problems if we select the correct background material to com-plement our subject. Seamless backgrounds come in a multitude of colors, styles and materials; selecting one that portrays harmony requires little consideration. Is the background masculine, or feminine? Will there be separation between the subject and background, or will the figure's hair (or other parts), blend into the surrounding? When these issues are met, there are usually no additional background problems.

When we are shooting candids, or indoor environmental portraits, the background must be considered carefully. Are there glass objects (windows, mirrors, lamps, etc.) that are brighter, or lighter than the subject? Unwanted reflections have degraded many otherwise great portraits. Is daylight streaming into our composition through a window, overpowering the person that is to be the center of interest?

Conversely, is the person in the center of a room? An on-the-camera flash may illuminate her properly, but not reach far enough to properly light the background. Usually a black background is as detrimental as a burnt-out one. Rather than trying to overcome problems of either type, it is advisable to reposition the subject, or change camera position. A few tests with your equipment will confirm the above statements.

# symmetry

Symmetry is the ultimate representation of order. Butterflies are a prime natural example. Many formal buildings, from the ancient pyramids to modern office structures, were designed using the symmetrical approach. Some individuals love symmetry and deplore asymmetrical compositions. A symmetrical composition can be a rewarding experience, or a boring one. If you wish to play it safe, a symmetrical finished product will never put you on a slippery slope; however, it may not generate excessive excitement. Probably a pastoral scene requires symmetry. This image category is sometimes called static composition.

By dividing a picture in half (a mountain reflected in a lake) we create a symmetrical composition, but give equal importance to each half. Call this boredom or two competing images; either way, this is probably not we are trying to achieve.

If you are photographing a building for a client, a straight-on shot may be what he desires; but if you wish to put an artistic spin on the result, try some less formal rendition. Shoot every job in as many ways as you can imagine. A little extra time shooting extra exposures is a good investment.

*In ancient times, Chinese authorities placed this temple at the precise spot that was considered to be the center of the earth. I thought it fitting to produce an image in which the temple is centered. This composition typifies a symmetrical treatment of a symmetrical subject. Some asymmetrical relief is achieved because the stairs do not ascend via the center of the frame, and the human figure is strategically positioned to create harmony. Try to picture her entering the frame from the left side of the stairs. If you can visualize that, you can see how individual picture elements contribute to the whole scene.*

*Notice the similarity between this image and the image on page 105. They are both examples of how asymmetry can be stimulating. In some respects, the two shots are similar; in others, they are completely different. Also, please notice that a black-and-white image and a color shot can impart the same viewer response. The fact that one was captured on the California coast and the other in the middle of Spain has little effect on our feeling about either image.*

## asymmetry

Most pleasing compositions are asymmetrical, but unequal elements are used in such a way as to create what is sometimes called dynamic balance. We have already discussed balance, and we know how balance is achieved. Remember what we discovered when we were learning about balance. Nothing has changed, except that we are now commingling thoughts about the two compositional aspects; soon we will add additional ones to the mix. Surprisingly, these elements, thought of as a whole, simplify our task. If you are not convinced, think about it

this way; balance, asymmetry, image placement, and some lesser considerations are actually just different ways of viewing one major aspect of composition. Broken out and discussed separately, we obtain the solution via different thought processes, but all of them direct us to the same conclusion.

Dynamic composition is often achieved by the use of a strong diagonal. Nonsymmetrical balance can then be achieved by the precise placement of this diagonal in our frame. Again, multiple

*Balance need not be symmetrical. A small area of lightly colored subject matter can offset a darker one. This image could have been recorded anywhere; the fact that it was captured in sunny Spain has no real significance. What is important is that the light and dark shapes are in harmony. Notice that this more than mundane structural composition becomes interesting due to a strong sense of balance.*

compositional elements must commingle to help achieve the desired result. There are more interlocking puzzle pieces; please add additional ones as you learn. For now, I will throw in one additional comment, and then we will move on.

The dynamics of composition evolve about the principles of asymmetry. The Fibonacci Numbers generate it; the golden mean creates it. We must learn how to harness this powerful illusion if we are to create great images.

# light

9

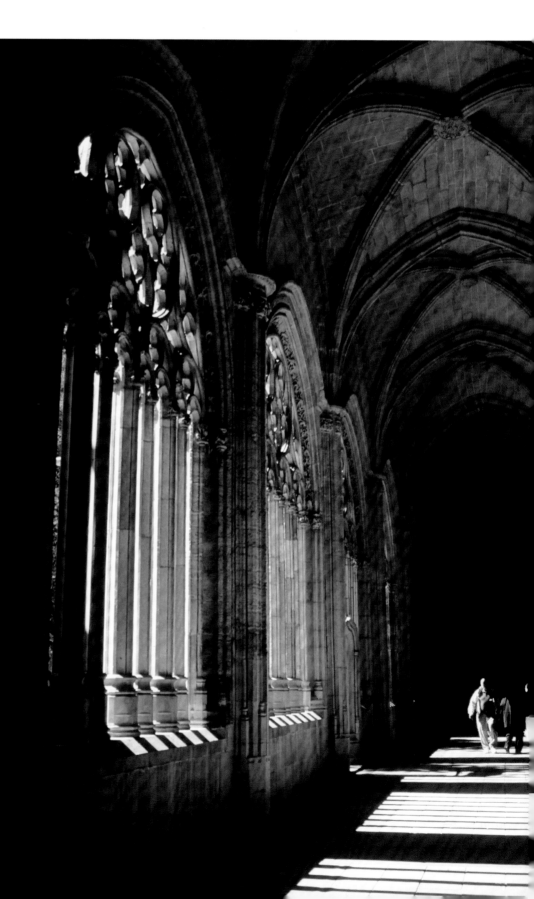

*The light streaming through the windows and creating geometrical shapes on the ground makes this image work. The figures on the right serve to add dimension and scale to the grandiose structure.*

**ALL YOU NEED TO KNOW**: Light exists in a finite number of ways, and a very important part of composing a great image is awareness of the light you are working with. Earlier we discussed keeping notes on the situations you encounter while taking pictures. Include a description of the prevailing light in your notes and apply what you learn to similar lighting conditions in the future. The experience you gain from "reading the light" will give you good image results time and time again.

## all light is good light

Light is the essence of photography. It is our task to determine what type of light is proper for each intended subject. Sometimes it should be thought of the other way around. What will photograph well in the given lighting conditions? If that sounds foreign, think about this: the greatest subject, incorrectly illuminated, will produce a flop. A mundane object, superbly lighted, might be a masterpiece.

If we go out on a given day to take photographs, we encounter light-du-jour. Under these conditions, it is best to look for a subject that will be properly represented in the prevailing light. A heavily overcast day is a good opportunity to photograph flowers and other small compositions. Bright sun with a clear sky is ideal for a scenic photograph, but can often be too contrasty for close-ups.

In a converse scenario, we have pre-selected our subject and anticipated the correct lighting conditions. If the image is that important, we must arrive early, set up, and be ready to shoot as soon as the light is proper. The ultimate waste is going through a great deal of trouble to prepare, yet arriving minutes too late.

Regardless of the reason why we are shooting, when dealing with light, quality, not quantity, is of the utmost importance. A photographer who has a sturdy tripod can photograph at any light level if subject movement is not an issue. Great images have been created, illuminated solely by moonlight. Sometimes low-intensity light is an advantage; images of water moving as a blur are sometimes more effective than frozen-motion shots. When the light level is low, slow shutter speeds are easier to achieve.

Now let us consider the major aspects of light that govern our ability to make great photographs. Remember, this is not a book that will cover every aspect of light and lighting. We will discover those qualities that concern our ability to convey our feelings, the mood we wish to impart, and our reasons for creating the image.

# the quality of light

The two main aspects of light we must consider are its quality and its direction. These control most things of concern to us when the shutter is snapped. "Go for the light" is the term we should keep repeating to ourselves as we set up the shot. If we have correct lighting and proper image placement, we are well on our way to a rewarding experience.

Basically we can break down light into two categories: hard or soft. Hard or harsh light is direct light, usually from a single source, shining directly upon our subject with nothing between it and the scene to soften it. Sometimes hard light can come from multiple sources, creating multiple shadows. Soft light is light that has been diffused or bounced. In nature, this occurs when light passes through clouds, haze, fog, or leaves. It creates a softer shadow and less contrast in an image.

An excellent way to study light is by observing the absence of light. Study the shadows! Shadows will reveal many things we need to know about the direction, angle, intensity, quantity, and quality of the light source. By studying the shadows we can understand the source. At the instant of exposure, or when viewing a finished image, shadows are our most important clue to the prevailing lighting conditions.

If you see a dark shadow with sharp, well-defined edges, the light source was unobstructed. If the shadow is not well defined and of lower contrast, you know the light source has been diffused. If you observe multiple shadows, you know that there were several light sources. In the studio, multiple shadows are considered an example of poor lighting.

You may or may not be able to control the quality of light, but the subject and mood should match the lighting conditions. Strong, contrasty light may be what you want when you are photographing a male subject, especially a so-called character shot, but that type of lighting is usually not appropriate as a lighting set up for women and/or children. Flowers usually are rendered to their best advantage via softer illumination; scenics may require either hard or soft light. Let the mood you are aiming for be the determining factor.

*This composition can illustrate several key compositional points, but it would be a poor image without the proper quality of light. Captured in the Roman ruins of Ephesus, Turkey, it creates an almost art deco impression. Before any other considerations, we must be sure that the lighting is correct. All light is good light, but without the proper light, any image will suffer.*

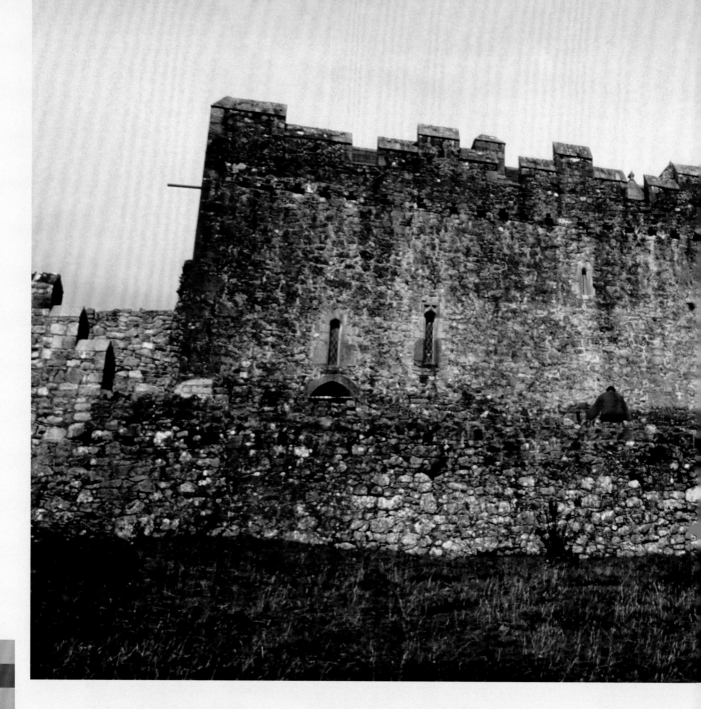

## front light

Front light is what the name implies, light that emanates from directly in line with the camera. It illuminates the subject head-on. Light from this direction creates minimal shadow area, and illuminates much of the scene in a uniform manner. When copying flat work (documents, photographs, paintings, etc.) soft, flat, front light is desirable. When we want to show maximum detail in every part of the frame, front light is the directional light of choice. At other times front light may create more problems than it solves.

Built-in or on-camera flash is an example of front lighting, and since it emits light from camera level, it creates an even less desirable condition. Because the light source is too low, instead of shadows that drop below the subject, large shadows

This image of The Rock of Cashel, Ireland, is a prime example of an image illuminated by front lighting. There is a bright sky, yet few shadows. There is detail in virtually every area of the print. Front lighting is usually difficult to work with when attempting to produce pictorial images. The one element that justifies this composition is the effect created by the red coat.

surround it. Whenever possible, use the bounce flash technique; since it will usually produce more pleasing results. We were always accustomed to seeing subjects illuminated from above; the widespread acceptance of flash pictures has somewhat accustomed us to this lighting scenario, but it is much more pleasing to view objects that are lit from a source that is higher than camera level.

In the field, we also need to consider the light source. As stated above, front light usually produces the flattest subject rendition. The three-dimensional illusion is reduced and the image may inspire boredom. The illusion of depth, the ability to judge the shape of objects and related effects, are dependent on shading.

*This close-up rendition of a portion of the Arizona desert floor is not precisely a front-lighting shot, but maximizes the viewable detail. Notice also that the shadows indicate a slight cross-light pattern.*

A good black-and-white photograph should have a small area of pure white, and some area of jet black. There should also be a complete range of tones that bridge the gap from highlight to shadow. Color images should usually emulate the range of a black-and-white print, but here we may be dealing with variations of color and/or hues. Remember, there are no rules; some exceptions to the above enliven the mixture of exciting finished products.

## side light

Side light is of the utmost importance to photographers. It will usually produce the most favorable results when we are considering images in general. It produces good highlights, excellent modeling, and pleasing shadows. To some degree, different media require different ranges of contrast. Learn the sensitivity of the medium you are working with, and live within its optimum confines.

Direct light can emanate from only one narrow angle, yet side light can originate from any position other than directly in front, or behind, the object or scene. In

*"The Death of Pan." I rarely title my photographs, but in this case a title is appropriate. Generations of Southern Californians attended many events in the Pan-Pacific Auditorium. Most were saddened when it was slated for destruction. Just before it was demolished, I made this bittersweet rendition. Even in desolation, signs of greatness shine through. In this image, excellent side lighting assisted in the impression I sought to convey.*

other words, all side light is not created equal. The crafty photographer will use this fact to good advantage. Light that is slightly to the left or right of center produces smaller shadow areas than light coming from a 90° angle. Again there are no rules, but a preponderance of pleasing images are produced when the light source (in the studio or on location) is at a 45° position. If there are any criticisms of this type of lighting, it would be that side lighting will not often produce unusual effects. Good sense tells us to first play it safe, and then experiment.

*Optimizing the ambient light affords endless possibilities. You can never exactly replicate a previous ambient light situation. This is a double-edged sword. Reproducing a previous setup is virtually impossible, but new opportunities present themselves every time.*

## back light

The name says it all; the light is shining directly at the camera from behind the subject. Back lighting can create stunning results, fabulous images, or disappointing failures. Light emanating from behind the subject has the highest contrast of all the different types of light. And if we are not careful, this light source can also produce lens flair (reflection within the individual lens elements).

Striking portraits can be obtained with the use of back lighting, but not without some front-light augmentation. We are free to use a wide variety of sources for this light supplement: the side of a building, a hand-held reflector, or a flash can be used in outdoor locations. Even the

flash built in to the smallest point-and-shoot digital camera can create unique examples of this type of candid portrait.

In the studio, portraits illuminated in a conventional fashion can be enhanced via a light from the rear of the subject to separate the subject from the background or to create a halo effect. However, use this judiciously; this style of lighting can easily be over done.

When shooting inanimate objects, we have more leeway. Sometimes, full detail is not what the scene requires. We may be better served with a partially disclosed subject; we may even find that a silhouette best serves our purpose. This is also

another aspect of photography that requires us to be fully aware of the limitations of our recording media. How much contrast can create superb results? How much will blow out the scene? Even the most experienced photographer should hedge his bets when shooting back-lit subjects.

Now that we have briefly considered the direction of our light source, let us consider its elevation. Light coming from directly overhead is said to be emanating from a 90° position. High noon shots usually yield little more than record shots. As a general rule, conventional studio lighting strikes the subject from a 45° angle. In the field, that angle will produce pleasing highlights and shadows, but variation is the spice of photography. For example, when the sun is close to the horizon, spectacular images may result.

As sunlight passes more obliquely through the earth's atmosphere, it takes on some photo-enhancing qualities. Its color becomes warmer, it seems to produce a glow, and shadows take on a mellow attribute. Digital, transparency, and negative media all benefit from this type of light. No wonder some photographers designate these times of the day as the "golden hour."

*Backlighting plays an important role in this image of a boulder captured at Death Valley's Racetrack. Scientists do not know what propelled these rocks along the playa of this dried lake bed. Conjecture abounds; mystique helps make the Racetrack a fascinating photographic study. I consider myself to be primarily a black-and-white photographer, but this color shot is more appealing.*

When atmospherics are favorable, these lighting conditions occur some time shortly after sunrise, then again before sunset. This magic hour is not actually a precise one-hour duration, and the time from sunrise/sunset is not always the same.

# perspective

# 10

*Getting close to this flower gives it importance in the frame, as well as revealing detail within it's bloom.*

**ALL YOU NEED TO KNOW:** Perspective is a function of position and distance. The beginning photographer uses lenses of different focal lengths to bring objects closer or to include a wider angle of view. The more experienced shooter discovers that lenses can work as perspective-controlling tools. Few photographers realize that different focal-length lenses do not affect perspective. More precisely stated, it is the subject-to-camera distance that actually creates this illusion.

We will not go into all the 'whys' of this phenomenon; just think of this one example that proves my point. Extend your hand to arm's length. You can use your hand to completely cover an automobile that is fifty feet away. Certainly, your hand is not larger than an auto, and you are not using photographic optics. The effect is created by the relative distance of eye-to-hand and eye-to-car. Having covered that, let us move on to other aspects related to perspective.

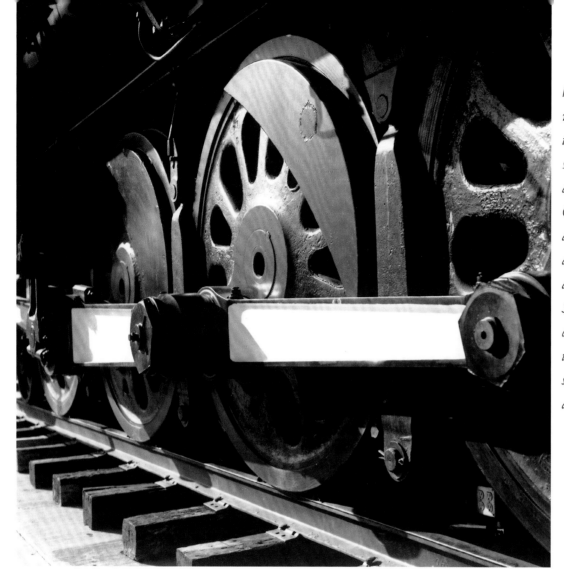

How massive do these locomotive wheels appear? If I had photographed them from a normal standing position, they would appear far less impressive. Objects, animals, and individuals should be photographed from a viewpoint at their level unless an alternate effect is the goal. Shooting down upon the subject diminishes its stature; shooting up (as I did slightly in this shot) makes it appear larger and stately.

## point of view

Most humans are used to viewing objects from a position somewhere between four and seven feet above ground level (depending upon their individual height). When a photograph is captured from a position other than normal, it creates a scene that presents a different point of view. This may create excitement in itself and enlarge on our way of seeing. Sometimes, changing camera elevation is essential in creating the best possible result.

Consider the photograph of a small child, or an animal. The most pleasing representation of these close-to-the-ground subjects will be obtained if the camera's lens is positioned at the subject's eye level. Looking down on a subject creates an effect that is precisely what the description implies.

Conversely, shooting at a person or object from a low angle, so that the lens is tilted upward, elevates the stature of that person, place or thing. In other words, we can glorify or belittle a subject by choosing a low or high camera angle.

In addition to camera elevation, we also usually have the choice of shooting an object head-on, or from an oblique angle. Let us consider the portrait of a single person. The most pleasing representation of the human head is obtained when it is captured as an oval. Shooting a person who is facing directly into the lens will yield the roundest representation possible, especially if we are using flat lighting. A person with an extremely narrow face should usually be captured in this manner. A person with a round face will be more pleasantly represented when shot from the side, while illuminated with more contrasty side lighting.

That same knowledge will serve us well in the field. Low angle, high angle, head on, and oblique positions are simple tools that allow us to impart to our viewers how we feel about our subject matter. And of course, we can use this knowledge to our advantage, should we want to "break the rules."

## plane relationships

Plane relationships are actually part of the following normal, expanded, and compressed perspective sections of this book, which we will encounter next. They are, however, important enough to be given special consideration. We usually consider planes as a strictly horizontal aspect, yet we really need to be aware of vertical planes, and we need to consider planes in terms of shading (light to dark, and/or dark to light).

Near objects are seen more clearly than distant ones; close-up planes are usually darker and contain more detail and contrast. As planes recede, they progressively fade in intensity. This is one of the landscape photographer's best depth-creating devices. In the vertical position, buildings that recede down the street can create the same illusion. After a brief explanation about scale, let us discuss how we can render planes (and other picture elements) in a normal, exaggerated, or compressed representation.

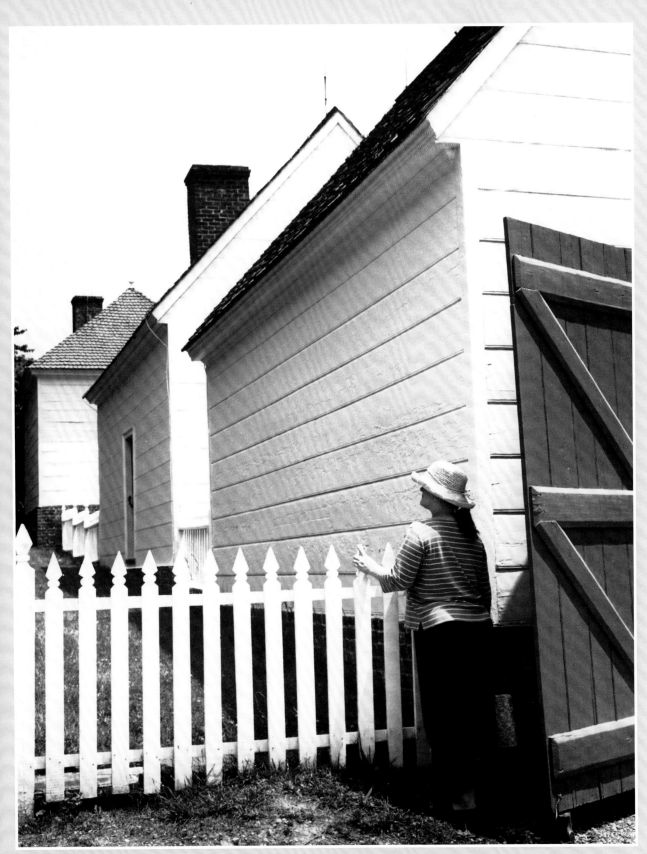

Plane relationships are usually demonstrated by using a scene containing hills and mountains that recede into the distance. The closer planes are darker, and contain more contrast; receding planes get fainter as they fall further away from the lens. In this example, the perspective is subtle, but the effect is the same. Shot on the grounds of Mount Vernon, the outbuildings also show recession; the rooflines form a broken diagonal, and with the closest two buildings, each rooftop is lower in the frame than the one in front of it.

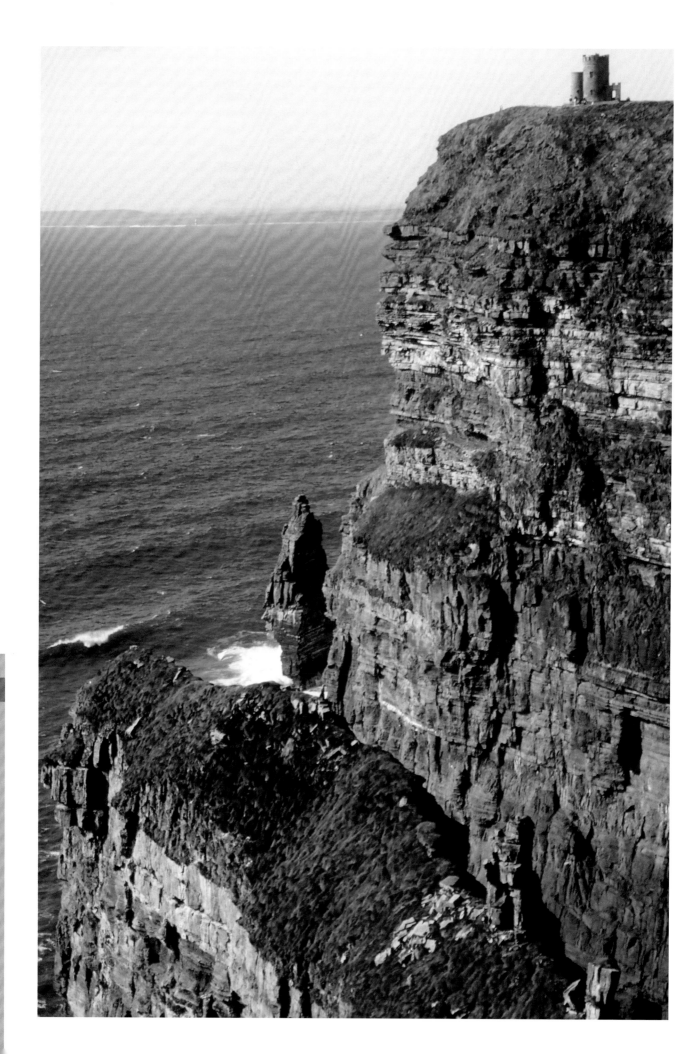

*Ireland's Cliffs of Mohr are more then impressive. They tower above the incessantly crashing ocean. One cannot realize the immensity of these giant formations unless some comparative element is included in the scene. In this image, the castle shows how massive the cliffs truly are.*

## scale

Scale can be a very important aspect of composition. When we are dealing with objects of unknown size, some recognizable object puts things into perspective. The picture on page 120 is a good example of what scale can do to improve the impact of an image, while the images on pages 24 and 25 do nothing to convey how massive the rock formation really is.

Notice the two images on page 121 of the Aurora Borealis. In the top image, there is nothing to express the vastness of this phenomenon; however, in the image below it, you can see the lights stretching across the entire visible sky. For a viewer that has never been to Alaska and seen the Northern lights, it night be hard to imagine their true size without this indicator of scale.

Personally, I often include a human figure in the composition; it not only personalizes the image, it is also one of the best indicators of scale.

*This strong vertical composition of the Aurora Borealis displays the colors that are most difficult to capture, and shows the effect that experts call "curtains". Auroras present themselves under viewing conditions that are less than comfortable; they appear during winter months in areas not too distant from either pole, but the reward of seeing a great aurora greatly offsets any discomfort.*

*This horizontal aurora image lacks the difficulty exhibited in the vertical composition above, but is possibly a better image because of the human element present. When we introduce some human figure, or in this case a habitat, the scene is given scale. We as viewers feel more welcome to project ourselves into the frame.*

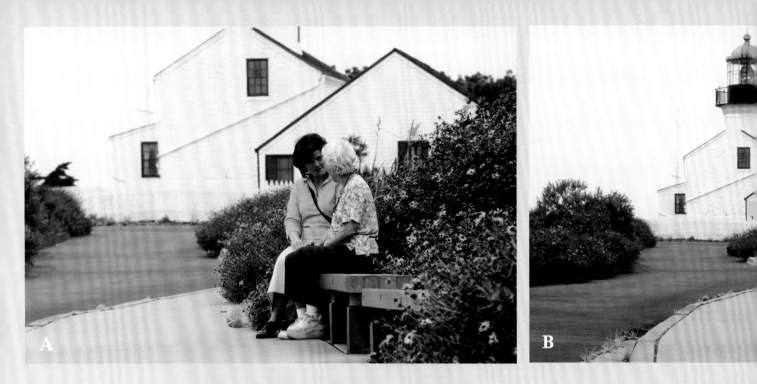

A

B

## normal perspective

Normal perspective refers to the way normal focal-length lenses represent an object. We are so used to viewing pictures, we usually do not compare the slight perspective difference between what the human eye and the normal camera lens sees. Spatial relationships between various picture elements are represented normally, and usually that is a good way to represent a scene. Objects have natural depth and contours, planes recede in a natural manner, and all is well in the world.

There are many photographers who claim that they never use a normal lens. If they believe that is their claim to uniqueness, so be it. Every focal-length lens has its purpose, but if you choose to ignore the most important tool that lens makers can offer, that is your prerogative. It is my humble opinion that a normal lens is called a normal lens, because that is the lens you should normally use!

How do we discover what a normal focal-length lens is? A normal lens should have a focal length equal to the diagonal of the recording media. For a full-frame 35mm camera it should be 42.5mm. Early lens construction issues caused a 50mm lens to be considered normal. Though not exactly correct, it is close enough for our purposes. Most D-SLRs have a sensor that is smaller than 35mm film, so a 35mm focal-length lens would be considered normal. Most medium format camera users consider 75mm or 80mm normal. For other camera formats, consult instruction books, web sites, or manufacturer's information phone banks. For your digital camera, be sure you know your precise camera model before making inquiries.

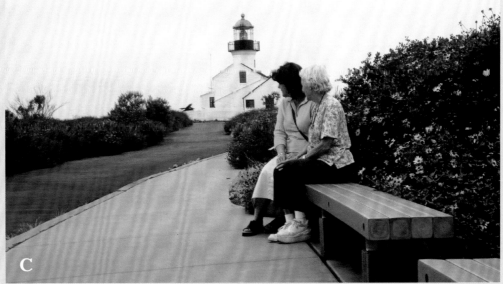

C

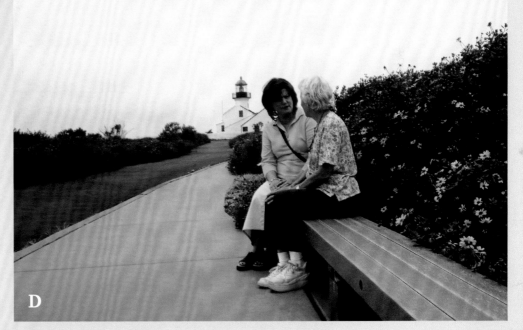

D

In these illustrations of expanded, normal, and compressed perspective, the human subjects remain basically the same size in the frame, but the lighthouse in the background changes. Each image was shot with a different focal length lens. Example A was shot with a 200mm lens, B with a 100mm lens, C with a 50mm lens, D with a 28mm lens, and E with a 15mm lens. All five shots were made from a tripod that was set at a consistent height. If I had lowered the camera angle on example E, I could have dropped the lighthouse completely out of the frame.

E

123

*These images illustrate the perspective altering effect of the camera-to-subject distance in a different way. Example A was taken with a telephoto lens (200mm), example B with a wide-angle lens (15mm), and example C with a normal lens (35-50mm). Notice how example A flattens the perspective and compresses the statue against the background, while example B isolates the statue from the background. These two images were captured from the same camera height, but in example B the base of the statue completely dominates the scene because of its close proximity to the camera. Example C (shot from a different angle, at a different time) shows how the statue should be represented.*

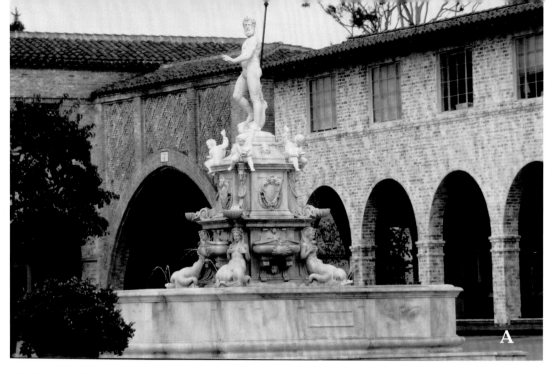

A

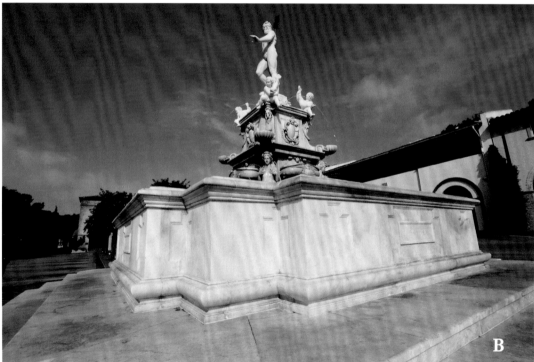

B

## expanded perspective

We use wide-angle lenses to separate close objects from their backgrounds. This function is sometimes more important than the lens's ability to include more angle of coverage. Wide-angle lenses allow us to get closer to our subject; therefore, the relative distance between the lens-to-subject and lens-to-background has been altered. This is the easiest way to create expanded perspective.

Expanded perspective is helpful when we wish to isolate a person or object. With care and planning, distracting elements behind our subject can completely disappear. At other times, the background may

need to be included in the scene, but accept a lesser roll in the overall composition. Wide angle lenses can cause this to happen.

What is a wide-angle lens, and how much will it alter perspective? Theoretically, any lens with a focal length shorter than normal is a wide-angle lens, and the shorter its focal length, the wider is its angle. The wider its angle, the more it creates the expanded-perspective illusion.

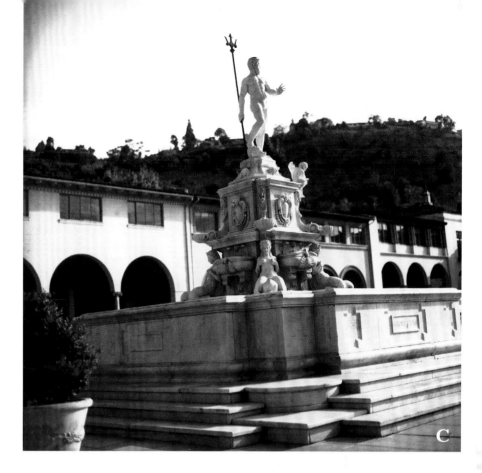

## compressed perspective

Compressed perspective is the exact opposite of expanded perspective. In scenes where we wish to show a comparison between near and far objects, making them appear closer together helps accomplish that goal.

Rhythm and pattern shots are also facilitated by compressed perspective. Stacking similar objects close together emphasizes the 'music for the eye' effect. Often we encounter pattern shots, photograph them, and are disappointed with the results. This failure is often due to our eye/brain magic; the eye sees the rhythm and the brain compresses the perspective, without our slightest conscious effort. The camera/lens combination is not (yet) a thinking device. We must cause it to compress the scene. We accomplish this compression by moving

away from the picture elements, and then cause them to fill the frame by the use of a telephoto lens.

Compression is greatly aided by extreme telephoto lenses. When thinking about compression and expansion of perspective, we need to think in terms of percentages. If you have a lens set at 30mm, and then zoom down to 24mm, that is a 20% decrease in focal length. If a telephoto lens is at 300mm, a similar decrease in focal length would position that lens at 240mm. Thought of in another way, a few millimeters difference in shorter focal-length shots must be equaled by substantially greater change at the telephoto position. Because digital point-and-shoot cameras require shorter focal-length lenses, the above numbers would not apply; but, the theory of percentage change would be applicable.

# color & shades

**ALL YOU NEED TO KNOW:** Everything you could learn about color would fill volumes, but color (as well as shades of gray in black-and-white images), as it pertains to composition, involves some rather simple elements. Please study the following text and illustrations to see how important these factors are to your compositional efforts.

## 11

## color theory

Most of us see light and shadow in a similar way, but every person perceives color differently, the extreme example being the colorblind individual. You must also consider that different media, and even different lenses, reproduce color in different ways. Each digital system also has its own way of reproducing color.

Before we delve into theory, we must learn the idiosyncrasies of our system, and how to calibrate it so that it renders color in a pleasing manner. The most intelligent solution is to correct color balance in the camera. Digital darkrooms offer another chance at correction, but at a greater expenditure of time.

*Color need not be brilliant to be effective. Subtle color can make its own statement. This isolated little boat could be anywhere in the world. In fact, it is a sunrise surprise in the harbor of Carragiholt, Ireland. It is a surprise because most of the morning shots were made with my camera pointed in another direction, capturing one of the most colorful sunrises that I have ever seen. By chance, I took one shot of the single boat and muted reflections. It turned out to be the shot of the day.*

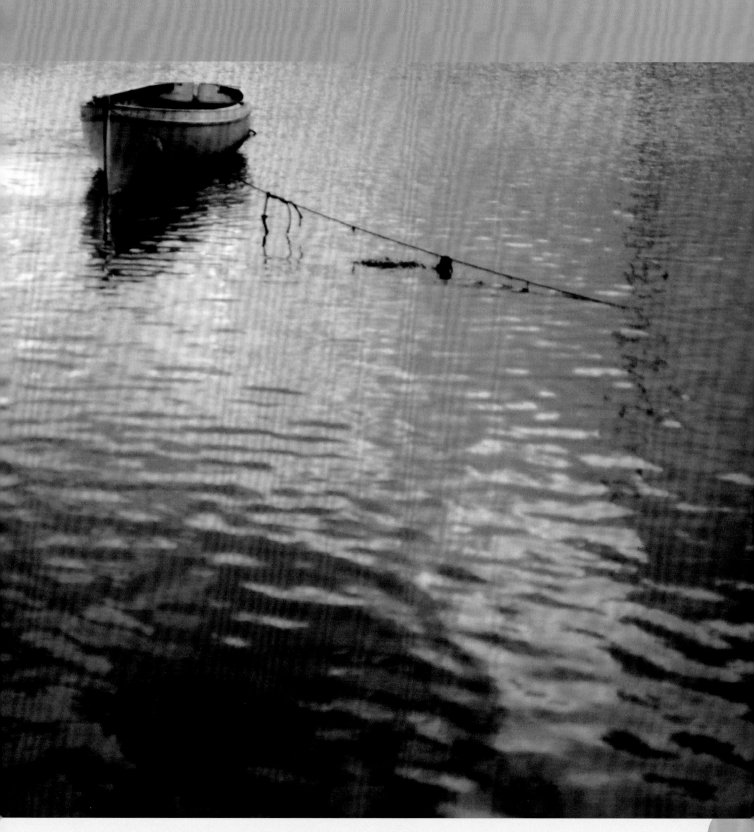

If your digital camera consistently reproduces color in an unpleasing manner, your first line of defense is to change the white balance via the menu. A camera that constantly yields images that are too cold (blue), in bright sunlight, might give excellent results when set at the "cloudy" setting. In other lighting conditions, experiment for the solution. Usually, auto white balance is the first setting to try.

Another approach to satisfactory color balance involves filters. Unfortunately, manufacturers of point-and-shoot cameras construct these cameras with scant provision for attaching filters. However, cameras with larger lenses often have the threaded ring that makes filter attaching simple.

If you have a multiple lens outfit, and all your lenses were supplied by the camera manufacturer, all your results should be consistent. But if you own some after-market lenses, color balance may vary from lens to lens. Color-balancing filters for these lenses will be your best solution. Of course, with digital, you can make a menu change each time you switch lenses, but do you really want to do that?

Few of us are printing high-quality color at home, so we must contend with an outside source for our final prints. Finding a good lab is essential. It is foolhardy to own high quality camera gear and rely upon the least expensive source for

prints. In this ever-changing marketplace, a good camera store is the best place to obtain quality printing.

For those lovers of the digital darkroom, be aware that printing at home involves color management. The monitor must be in agreement with the printer, and both must be calibrated to the ink and paper being used. Some sophisticated home printers have hired experts to calibrate their system, because of the savings in time and frustration. Once calibrated, consistency is the key word.

Now that we have confidence in our image-capturing system, we can concern ourselves with the proper use of color. Color is a joy that must be felt by the photographer before its compositional importance can be passed on to the viewer. There are some "rules" that explain color theory, but they should be used to understand why we react to color stimuli, rather than becoming the driving force that controls the way we use color. In other words, if we follow rules too closely we limit our scope.

The most important color theory tool is the color wheel. On it are placed the brightest colors with maximum differentiation. The lightest color on the wheel is yellow, and as you move away from yellow the colors progressively get darker. The colors on the red side of the color wheel are considered to be warm, and

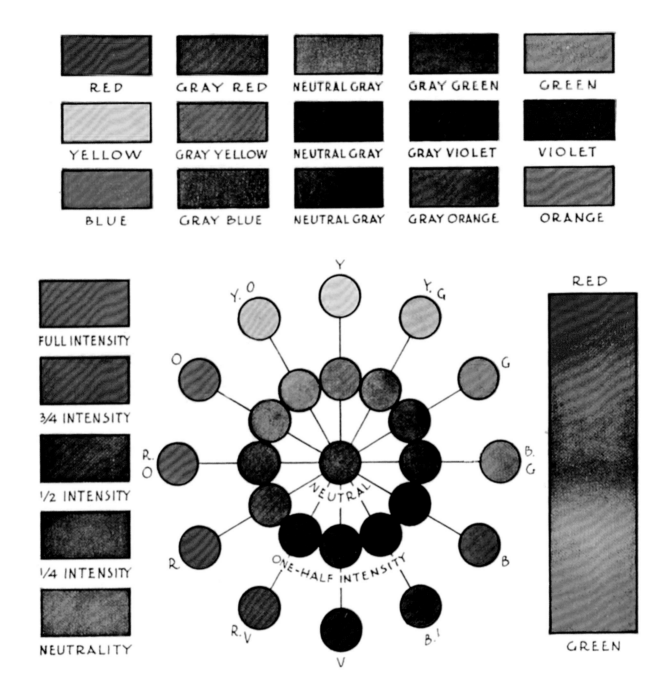

A color wheel shows the relationship of colors, one to another. Colors that are directly opposite one another are said to be complementary colors. These colors, when used in close proximity, produce intense color contrast. Colors that are near each other on the wheel create a softer, less vibrant effect. Neither above scenario is good or bad; each merely produces a different effect and viewer response. The intelligent photographer can use this knowledge to great advantage.

*The subtle color of the Iowa farm hay rolls supports the composition and creates a mood for the viewer to embrace. The slight warmth of the color adds life to the simplicity of the image.*

the colors on the blue side are said to be cool. To obtain the maximum color contrast, we would choose two colors that are exactly opposite each other on the wheel. These opposites are called complementary colors, and when used together produce intense color contrast.

Most people cannot picture a color wheel in their head, nor can they recite the colors of the rainbow from memory. I could not either, until I met my good friend, Roy G. Biv. The letters of his name tell us, in precise order, what those seven colors are (red, orange, yellow, green, blue, indigo, and violet). Now Roy is your friend too.

The following contents of this chapter could actually be considered in the blanket category of color theory, but they all have great importance in their own right. It is to our advantage to consider them as separate entities.

If you have had any previous education relating to color theory, you may possibly consider the following as an unorthodox approach, and I am not saying it is not. What I will tell you is that over the decades, I have attended many classes, read countless books, and done plenty of experimentation. What follows is a condensed version of the factors that I consider most important when thinking about color as it pertains to photography.

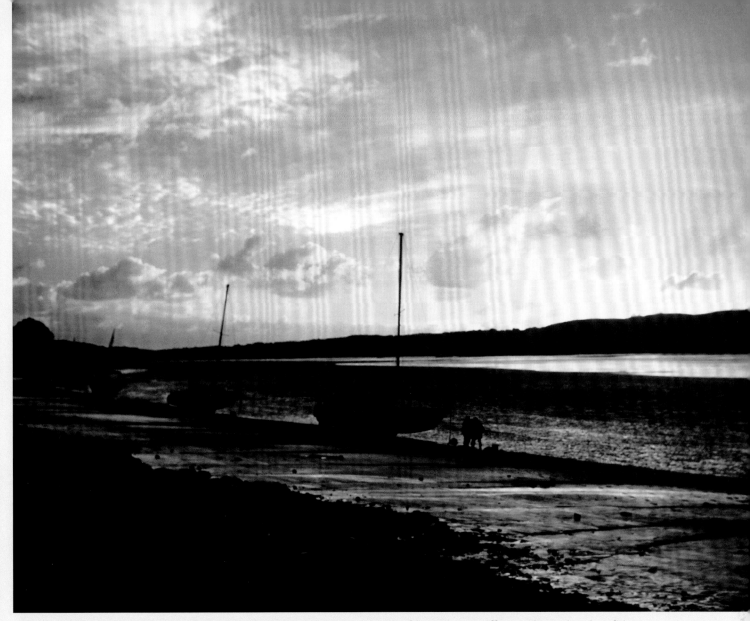

*This sunset composition, captured in England's Lake District, shows one example of how color can affect mood. Another shot of this same exact scene captured during high tide, during the middle of the day, would be a radically different representation of this shoreline. A wonderful learning experience could involve the capture of any impressive scene at different hours, and under different ambient lighting conditions.*

## how color affects mood

Color is one of our major tools, and informs the viewer how she should feel about the image. I mentioned in passing that some colors are "warm" and some are "cool." Let us explore that concept further, starting with the most important color of them all, red.

Red is the most symbolic color because it is so closely linked with mankind, and has been since early times. There are languages that intertwine the words 'red' and 'blood.' In some Semitic languages, 'dam' (blood) is the source of the word 'Adam.' From these origins came the word meaning red dust, again the name of Adam, or man. Red is the color of blood, fire, stoplights, and therefore, danger.

Conversely, one of the most beautiful of flowers is the red rose. And many other gorgeous flowers are red; I am sure you can name many. Red is probably the most popular shade of lipstick, especially if you consider all the various shades that have been offered over the years. Red is the color that predominates in the most spectacular of sunrises and sunsets. The red fire need not always be a sign of danger; the warm glow in a fireplace on a cold night is a most soothing experience. And what about that campfire; does it not address our nighttime camping needs?

As we consider other colors, we will discover symbolic meanings in all of them, but no other color has the intense and diverse possibilities of the color red. Used sparingly, or splashed over the entire frame, the color red will be certain to get viewers' attention. The ways that colors interplay in photographic images are in some ways similar to the effect they have in other fields of art, especially paintings. But there are differences; some are subtle, others are not. In no other set of colors is this statement truer than in the way a photographer addresses the use of the color red and all its variations. Use your personal treatment to generate some unique images.

The opposite of warm is cool, so let us consider the tones that are said to fit that category. Photographically speaking, when you think of cool, blue is the color that comes to mind. Blue is a peaceful and restful color. Blue skies are often found in poems and songs, and the bird of happiness is a bluebird. Blue water is usually peaceful water; it implies smooth sailing. The blue metaphors are endless.

Blue is a wonderful color when we want and expect it, but undesirable when it creeps into our image uninvited. Pictures taken on hazy, heavily overcast, or stormy days often have a blue cast over the entire image. This can also occur when images are captured in shade. If a given image is well suited by this effect, so be it, but usually the result of an overall blue cast is less than wonderful. Awareness is our first hurdle; correction (if possible) is the second.

Usually when experimenting, restraint is the key. However, when the eye sees even a little too much blue, it is not pleased, yet most viewers tolerate a reasonable amount of excess red. When I make warming color corrections, I first try my best guess, and then repeat the shot with even more correction. It is the rare occasion when I have overcorrected, even though I have not bracketed the filtration.

*The brighter color in this image punches through the would-be complex lines of this Costa Rican plant. Shown in black and white, this composition would lose its power.*

*While awaiting a spectacular sunset, which did not occur, I had seconds to reposition myself and grab this shot. If I had later added the figure into the scene with an image processing program, it would have taken substantial amounts of time, but then I could have placed her facing into the frame.*

Every digital system has a specific sensitivity to color. The human eye/brain combination corrects for various lighting conditions. To the eye, a white scarf looks white in sunlight, incandescent light, and fluorescent light. Cameras properly set to accommodate daylight conditions would render the scarf as white in sunlight, yellow under incandescent light bulbs, and green when photographed under most sources of fluorescent lighting. Of course, some digital cameras, set at AWB (auto white balance), may cope with most lighting conditions. The person who is learning his system is advised to test for the above conditions before attempting irreplaceable shots. Even the digital shooter should be prepared in advance; second chances at decisive moments might never happen.

After that necessary digression, let us consider the impact of other colors, and the next most important color for photographers is the color green. Green is the color of most living vegetation. It represents the season of spring. It can be lush and verdant. A scene containing a predominance of green suggests feelings of calmness and cool breezes.

Yellow is a most important color that is often associated with the warmth of the sun. It is also the lightest of the primary colors. The human eye is attracted to the brightest spot in any photograph, and will look at it first. We will go into more detail later, but for now just consider this; a bright yellow hat will place the visual impact where it should be; a bright yellow trash can, even in the background, can ruin the shot.

So far we have been considering colors selected from the color wheel, but what about other colors, shades, and tints? Do not be apprehensive; your natural instincts are your best guide. You know that brown is the earth color, the color of natural wood, and the color of tree trunks. Now cast your mind to an area completely removed from earth tones. No one has to tell you that the color purple is considered the royal color. If these divergent colors are that easy to psychoanalyze, you only have to think about how you feel when confronting a new color experience. The rest of us will be rewarded when we view your end product.

| | | | |
|---|---|---|---|
| red on white | yellow on white | green on white | blue on white |
| red on orange | yellow on orange | green on blue | blue on yellow |
| red on yellow | yellow on red | green on red | blue on orange |
| red on green | yellow on blue | green on orange | blue on red |
| red on blue | yellow on green | green on yellow | blue on green |
| red on black | yellow on black | green on black | blue on black |

*This illustration shows the importance of background colors; what I call "color on color." Across the top of the illustration, we observe the colors red, yellow, green, and blue, as they appear on a white background. When these exact same colors are reproduced in a field of any other color, our perception of their intensity and hue is altered. Notice how complementary colors intensify each other; conversely, when colors that are close to each other on the color wheel are used together, they produce muted results.*

## color on color

Before we delve into color pairing, we must realize that we will encounter two different situations. Sometimes we can select our color palate, but often we must deal with ambient conditions. The portrait of an outdoorsman might be an environmental one. You would have him dress in brown tones and photograph him against an appropriate background. Conversely, when photographing any particular house, you must deal with its surroundings. In either scenario, how well you think things through will determine your success. The time of day or night, time of year, camera position

and/or angle, the lens' focal length, and other factors all need be considered. The image on page number 145 involved waiting for the exact time of day and year when the sun cast the shadow of the wrought iron upon the bench in precisely the way that I had envisioned.

Any color can be enhanced or diminished by its surroundings. Verbal descriptions do little to explain what I mean when compared to the examples shown here. To appreciate the true color, study it on a white background, and then watch what happens when that color is surrounded by black. Next we see it with complementary colors, and finally with colors and hues from its own family.

After observing how the above phenomenon is able to bias our perception, let us consider a similar but different aspect of image control. Let us explore the effects of contrast.

## how contrast affects the image

Contrast is one of the most important forces that control our two-dimensional product. Without it, most pictures are flat, boring, and dull. Too much contrast can create chaos and confusion. As the architect of our images, we must control the use of contrast if we wish to produce successful results. In the section above, we have seen how color is affected by contrast, or lack of contrast. Black-and-white photography is affected to a greater degree, because tonal range is its essence. Said another way, a color image may have great contrast if two colors of equal density are adjacent, provided that they are from opposite positions on the color wheel. But a black-and-white photograph needs variation also, and its only resource is derived from contrasting shades of white, gray, and black.

I was once told that a good black-and-white photograph must contain a small area of pure white, and some area of jet black. All images will not fit into that formula, but on the whole, it is a good target to strive for. Knowing that this should be our norm allows us to be creative when we deviate. Hi-key and low-key photographs are impressive, when handled correctly, because they break the mold.

The same can be said of a color photograph. A pleasant outdoor scene will be enhanced by pure white and coal black. Again, all color images will not fit this model, but more will than will not.

One of the best ways to improve our compositional skills is to look at photographs. Nowhere is this statement more correct than here. At your next opportunity, study images with this specific goal. See which ones contain true black and real white. Do your favorites conform, or deviate, from this principal? Would that deviant, excellent picture be improved if it contained these contrast extremes? Remember, even magnificent works can often be improved.

The human eye is automatically attracted to the brightest area of an image. This is a most important fact. Please remember it! In a color image, the eye will first see the brightest color; in a black-and-white photograph, the eye is attracted to any, and all, of the lightest areas. The wise photographer will use this information to best advantage.

In the actual scene, or a photographic representation of it, dark objects seem to recede and light ones appear closer. This, coupled with the eye's attraction to bright objects, make it almost mandatory that your subject is the lightest object in the composition. Again, there may be times when we deviate from this principle when assembling our image, but those times are, or should be, rare.

Now that we know this, let us consider what happens when things go wrong. One of the most common mistakes that plague photographers is the inclusion of so-called "light traps." A light trap is a brilliant area that is brighter in intensity than the object of the photographic study. The most common of these occur when trees are part of the background, and harsh white sunlight comes streaming in through the leaves. In this scenario, there are usually multiple light traps. Each bright spot is saying to the viewer, "Look at me first!" This is pandemonium. Light traps always diminish the composition's impact.

Have you noticed, I believe in the adage, "Never say never?" Well, I did not say it here. I suppose there might be an exception, a time when light traps are beneficial, but I cannot think of one.

Do not confuse light traps with glistening highlights. The sun reflected in water or snow is an example of a highlight area. They should be a part of the main subject interest, not distracting side issues.

We have already discovered that a dark image is a somber one, while a light one is what its description implies. But each dark image can probably benefit from a bright spot; some area, no matter how tiny, that is much brighter than every other tone in the image. Conversely, a bright, light image will appear even brighter if there is some dark area that creates the necessary contrast.

*The contrast of the dark wheels against the white snow stabilizes this composition. The sidelight creates easy shadows and heightens the contrast.*

Tonal range is another issue. In a color image, creative use of color can make a strong statement, with or without tonal range. The possibilities are endless. Consider all the variations in color schemes that designers have used over the years. We can gain photographic ideas from other industries' uses of color. In the 1950s we had avocado green refrigerators, while some bathrooms were salmon and grey; later came southwestern color schemes, to name just a few trends. Who knows what is next?

A most important aspect of creativity in black-and-white photography is the generous use of graduated tones. The more shades of gray an image contains, the more pleasing it becomes. By that, I mean a beautiful print should contain the aforementioned paper-base white, as many shades of gray as the system is capable of producing, and some small area of jet black.

Digital black-and-white prints rely upon the type of printer, ink supply, and to some degree, the type of paper selected. Learning what works best is imperative. Another consideration is the time/money dilemma. Most of us value our precious time, and being frugal by skimping on inferior products is counter-productive.

## 12

*The stunning contrast of the deep black sky with the fireworks and city lights in Budapest, Hungary gives life to this nightscape. There are opportunities for great photos everywhere. Train your eye to be on the lookout for great moments, good light, and interesting shapes.*

**ALL YOU NEED TO KNOW:** We are all capable of responding to the same stimuli. Composition is the way of creating order in our photographs that other humans will respond to regardless of their training, education, and environment. Remember that photography is the universal language that lets us communicate with others from every part of the globe.

When we organize an image in a cohesive way, it is the equivalent of preparing a great speech, but our product needs no translation. As a matter of fact, if a picture needs explaining, it is not a good picture.

One of the greatest speeches of all time was The Gettysburg Address. It is also famous for its brevity. It is a lesson to us all. We should strive for image eloquence shrouded in simplicity. I will say again, "composition is the elimination of all extraneous matter." If you follow that tenet, you really do not need to know more.

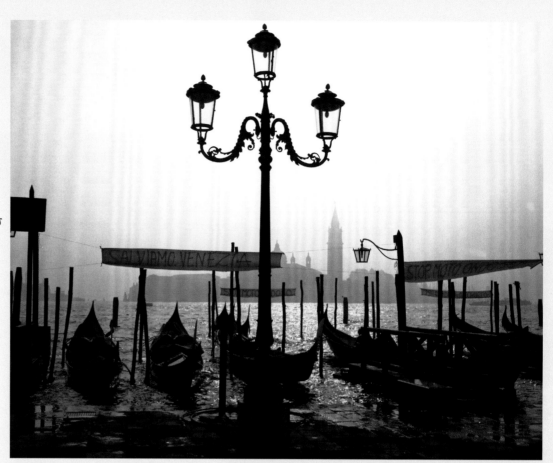

*This Venetian image proves that rules are made to be broken. How many times have we been told to never divide the frame in half? When I encountered this scene, I was enthralled. I made many different exposures and explored many angles, yet the images that complied with the rules were not as effective as this one. Decades of experience cannot be ignored, but new ideas must be perused if you wish to grow in your photography.*

## the proper approach

A positive attitude is essential, and there is no reason for anyone to be apprehensive about communicating in the universal language. We all have interesting thoughts to convey. If you create an interesting image, viewers will understand what you are saying. As you develop better skills, you will make statements more eloquently, but as you progress, as your skills improve, you are still awarded the opportunity to express yourself. Everyone is capable of producing great photographs; skilled artists are just capable of generating them more often.

Many great photographers have looked back on their early work and commented on the fact that they find their older images, the ones that made them famous, would be improved if they could have employed later skills to create them. We are all on a learning journey. If we do not improve, we stagnate. If this statement is true, it explains why we all look back at our early work with a critical eye. Images that we created early on, ones that we were proud of then, seem less than wonderful now. But viewers of our prints are usually not as critical. Do not fret; move on.

At this point, let me interject a parallel thought, which is my definition of a good photographer. A good photographer is one who only shows his good work. I say that because we all take some good pictures, and we all take others that do not measure up. No one takes masterpieces every time they trip the shutter. I have been telling students this for years. The quality of the images you show others defines your position in the pecking order.

The proper approach is to take one step at a time. The first step is to analyze your images. Are your recent ones improvements over earlier ones? Can you see a trend developing? Is there one flaw that keeps recurring? Are you so enamored of the subject that you ignore the surroundings? Do you devote enough time, on a consistent basis, to your pursuit?

Great accomplishments do not happen quickly, and consistency has merit. Any endeavor will be hampered if it is perused erratically. The mechanical aspect of photography should be second nature to you, freeing your total concentration where it belongs—on the composition of the scene. However, we need not be obsessive about camera settings. Modern cameras have taken much of the technical aspect of capturing an

image out of the equation. There are times when exposure or focus requires tweaking, but you will discover that you probably only use a limited amount of these settings. Do not try to learn and utilize your camera's every function. Use only what you need at any period of your development, but safeguard your instruction book. Our photographic involvement will change; refer to the instructions when needed.

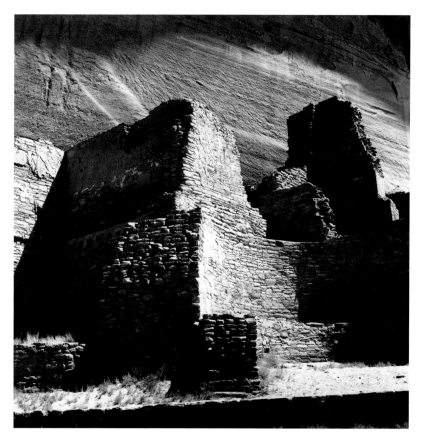

*Ideal ambient light creates this image of "The White House" in Canyon de Chelly. One aspect of making a winning photograph is to go for the light.*

# learning from others

Every photographer admires someone else's work. Study images that you admire, and remember that they need not be photographs. Some of my best inspiration comes from paintings. Also keep in mind that good ideas can be triggered by less than wonderful images. Often I see failed (in my estimation) pictures that contain some marvelous aspect. I store them in my memory bank for future use. Reconsider the statements in the above paragraph. Often when studying another's work, we can solve these problems by considering how someone else solved them.

When people ask me who my favorite artist is, I tell them that I do not need to have a favorite; it varies from time to time. If forced to choose a favorite photographer for his compositional treatment, I would select Andre Kertez, but the artist that I most admire is Piet Mondrian. These creative individuals may or may not strike a chord with you, but I recommend that you look carefully at their work to see what you can learn from them.

Just looking at Mondrian paintings can teach rhythm, pattern, subject management, image placement, and many aspects of color management. His intuition for the use of harmonious color, juxtaposition of complementary primaries and secondaries, as well as his precise placement of these chosen hues, can teach any photographer more than any amount of un-illustrated reading. These are not the only things Mondrian can teach. Among others is the symbolism buried in his works.

Please do not think that I am advocating that you copy the work of others. The world contains too many photographers that I call "triangle hunters." A triangle hunter wanders hopelessly over the entire area of Yosemite National Park, desperately searching for triangles formed by three dots in the sand where Ansel Adams placed his tripod.

We learn from others, but we must produce works that are unique, not carbon copies. When I find existing tripod holes, here is what I do. I compare the actual scene to the photographic representation.

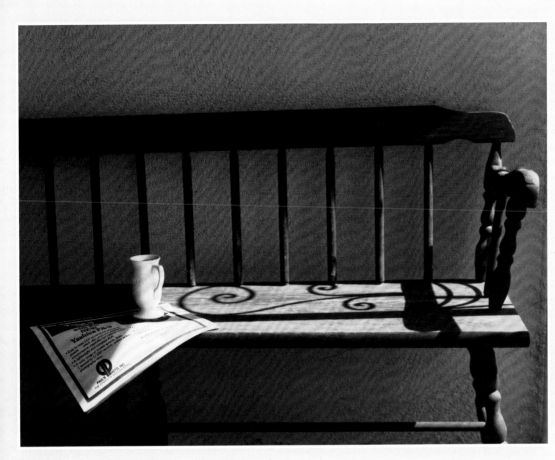

Here is the culmination of several attempts to produce the image that eluded me for a number of years. It is a tribute to patience. The shadow pattern cast by the wrought iron porch railing fascinated me. But the shadow only hit this spot for a few days each year. This example teaches that if an imagined image reoccurs in your mind, pursue it; the satisfaction is a great reward. It illustrates another point as well. It is my interpretation of what might happen if multiple image concepts are combined. How many famous studies can you find in this single image?

Next, I try to visualize a possible improvement via a change in lighting, camera angle, and the inclusion/exclusion of picture elements. Sometimes I have combined several key ingredients from multiple images, images created by photographers that I admire, to create my composition.

Be aware of the fact that virtually any object, location, or subject matter has already been photographed, yet these compositions await our interpretations. Simply by capturing old subjects digitally may produce effects that differ from a filmed rendition. Printers who take poetic license via computer-altering processes gain even greater flexibility. However, images should not be altered just because they can be; justification is required.

Purists believe images should not be altered; digital darkroom enthusiasts disagree. The truth is that virtually no photograph, captured recently, is unaltered. Most serious photographers place filters over a lens, wet darkroom users constantly change paper contrast, burn and dodge, and some even bleach specific print areas. These are but a few areas of image-altering controls commonly in use today. If an image is digitally enhanced, and the photographer so states, what could be objectionable about that?

## consider symbolism

Without going to extremes, we should be aware that symbolic representations are important. Without your knowledge, your images may be loaded with symbolic content, and viewers who may, or may not be equally unaware of the symbolism, are affected by the same stimuli. Often reviewers of books, plays, paintings, and photographs expound on the deep meanings incorporated in the work they are reviewing. I sometimes wonder if the author had that intent, or are reviewers admiring the emperor's clothes?

Regardless of initial intent, deep psychological content can be buried in any image. The saying "what you see is what you get" is not correct in this case; you get more than you see. If your hidden meanings appeal to a vast audience, you will become a great photographer. If you vibrate on a unique wavelength, you might never become recognized. However, if your new photographic slant becomes recognized, it may propel you into the spotlight. But what is important is that you convey your unique thoughts. Some viewers will appreciate your drumbeat, if you present it properly.

There are numerous books devoted solely to the interpretation of image symbolism, and the Internet also contains endless amounts of data on this subject. The more you know about embedded meanings, the more appealing your images will become. This can become a study course in self-psychoanalysis, so proceed with caution, but try to find out why the subject matter that you photograph fascinates you.

In Chapter 5, we touched upon the meanings of psychological lines, and Chapter 11 mentioned of the symbolism embedded in certain colors. It might be worthwhile to reread those pages with symbolism in mind.

How do we deal with a photograph, that two-dimensional representation of a real object that presents an object to the viewer, yet suggests something additional to the receptive observer? And even more worthy of concern, how do we make certain that all the image components are in agreement with both the apparent and subliminal message? Fortunately, if the visible components are in agreement, the symbolic meaning will usually be unsullied. Should a photographer wish to deviate from this straight path, many opportunities abound. Think of a song that everyone knows to be joyful. What happens when it is sung in a slow and soulful way? What similar opportunities are presented to the abstract photographer?

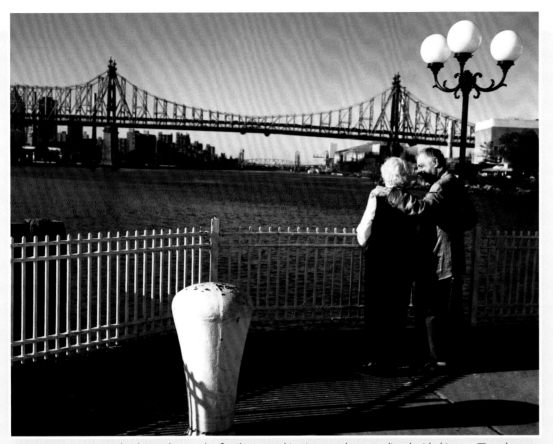

*A tourist is a person who drives thousands of miles to get his picture taken standing beside his car. Travel memories need not be this mundane, nor do they need to be "deer in the headlights" snapshots. Incorporate individuals into the environment. Try to invent a logical pose, one that corresponds with the theme and surroundings.*

## developing a unique style

If you do some related reading, and I suggest that you access several sources, you will discover that symbolism is not that difficult to understand. Another possibility is to simply look at images, and figure out what it is all about. At two ends of the spectrum are Georgia O'Keefe and Piet Mondrian. Understanding the Mondrian symbolism will require more thought and concentration. An analytical person may gain more insight by studying his early work first.

When you look at the work of famous photographers, you can usually determine the maker without having to be told his name. When an artist carves out a unique niche that separates them from their peers, when the work could have only come from one originator, we call that a style. This is the thing we must emulate.

By that I do not mean that we should copy another's style, but rather develop our own. This is easier said than done; developing a unique photo identity could take a dedicated photographer years to achieve. I know of no shortcut.

People tend to get in a rut, and that probably is not a bad thing. When a photographer continues to photograph the same type of subject matter over and over, because he likes it, rut becomes specialization, the building block of style. Cast your mind back to the paintings of Georgia O'Keefe; very few images she created were not of a flower.

Most photographers would not be content to spend their life photographing vintage doorknobs, but I know one who did just that for several years before moving on. Style, that nebulous thing, can be transported from parts of doors to studies of windows, or parts thereof. This, of course, depends upon the photographer's ability to impart a similarity to both groups of subject matter.

Many beginning photographers hunt for things to photograph, and while finding oneself, that is the correct thing to do, but the more experienced camera person should concentrate on a single subject. When you see a gallery exhibit, you usually see that sort of specialization. That should be a lesson to anyone. Single subject matter focus is the single best path to developing style.

The best approach is this: select your best image, analyze it, and try to use that knowledge to create similar images. When you analyze, use the following criteria: What makes it stand out? How was the subject treated? What other elements lead to its success? And finally, what similar image can you create, one that will build on the original, to create the start of a series? In other words, use your most successful result as the keystone to a series, improving each new image as your technique sharpens.

*The rhythm, pattern, and repetition in this image create excitement in an intriguing and dynamic photo.*

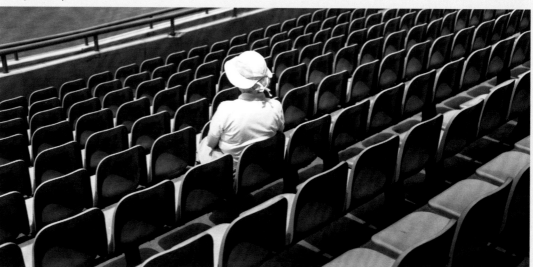

# it takes time

If you could take great pictures every time you picked up your camera, you would soon become bored and move on to another endeavor. You need a challenge, and photography offers many; composition is not the least of them. By continuously striving to improve, by charting progress as you develop, by improving upon past performances, you will blossom.

The person who sets goals and follows a straight path will arrive at his destination sooner than the one who wanders aimlessly. First, decide what it is that you wish to achieve, and then come up with a plan of attack. During each step of development, set attainable goals. If you are having technical issues, correct them first. High-end composition requires all of your concentration. The novice and the experienced photographer both face unique challenges when encountering a new image rendering. Yes, previous experience does make some aspects easier, but no two setups are identical, so previous experience is a guide, but not an absolute guarantee of success.

Learn your camera well, but only those functions that you really need. Modern cameras contain too much stuff; if you try to understand every feature and function, you will most likely be confused. Get a general idea what your camera is capable of, then use the controls you need now,

and remember others for possible future use. Safeguard your instruction book for future reference.

Practice. Practice. Practice. Study the work of photographers that you admire, but do not replicate their work;  put your own personal spin on the composition. As you progress, you will find yourself making your own statement; you no longer need to emulate others. At that point, you know that you have arrived, not at the finish line, but at the starting gate.

Be your own critic but in a positive and joyful way. Also get at least one other opinion. Find someone who will look at your work, offer positive suggestions, guide you in proper directions, and help you grow. Often this person has little or no photographic experience, yet they are gifted with the necessary insight you need.

Here is a tip that may help you analyze any given work in progress. It is my best personal analytical tool. I have an acrylic picture frame that allows me to quickly insert a print into it. This frame is in my living room; it receives ample light at all times of the day and night. I pass by it many times during each day. I do not stand and stare at the print that I wish to evaluate; I merely look at it as I pass by. At times, everyone's mood changes; at times perception is different; at times the lighting varies. All these factors cause me

to see my work print differently; usually, when I least expect it, an improvement solution pops into my head.

Always keep on file a specimen of the best print you have of each image. Make a record of how the print was made. I record that information on the back of the print. If you are a person who updates printers often, list the brand and model of the printer. If you rely on lab services for your prints, keep a guide print. A guide print is one that is sent with the reorder so that the printer can see exactly what you want. In any photographic printing process, there are many variables; the same technician from the same lab will usually reproduce the same file or negative differently upon each submission, unless there is a guide print to follow.

From time to time, you may wish to reprint old favorites. Often reprinting them will cause improvements to occur. Whether you reprint or not, look at your older prints and compare them to your new output. This is a great way to observe your progress, and it should assist you in determining the direction in which your work is heading. If you have a mentor, a comparison of old versus new images may cause him/her to notice something you overlooked.

None of the above is possible unless you have a way of retrieving files that you have accumulated. A proper filing system is mandatory. Digital shooters should store image files in at least two places. Digital images are easy to retrieve, if you have selected a good retrieval system. My definition of a good system is one that works for you. I would highly recommend that you use the same numbering system for images stored in your hard drive as you are using elsewhere, then your journal will aid in locating specific images. I devised my numbering system decades ago, and I have refined it multiple times. When I started shooting digital images, it needed no revisions. I am certain that when a new recording medium replaces digital imaging, my numbering system will be just as effective as it is now.

Once you get started with a system, it is easy to maintain. This system of mine, filing by date, evolved over several years. At first I tried other methods of grouping. Early on, I tried to categorize by subject, and got completely mired down. I created a file for Shirley, one for Tammy, another for Mark, and so on, but what could I do with an image that contained Shirley, Monica, and Michelle in Switzerland? Filing by date was the obvious solution.

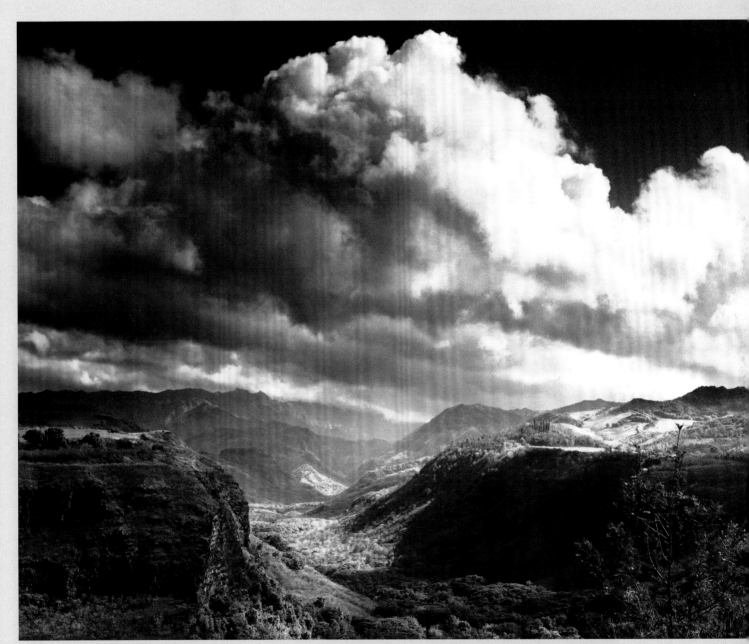

*Huge, billowy clouds balance the mountains and valleys below in this picture, adding a powerful fullness to the entire landscape and creating an impressive composition.*

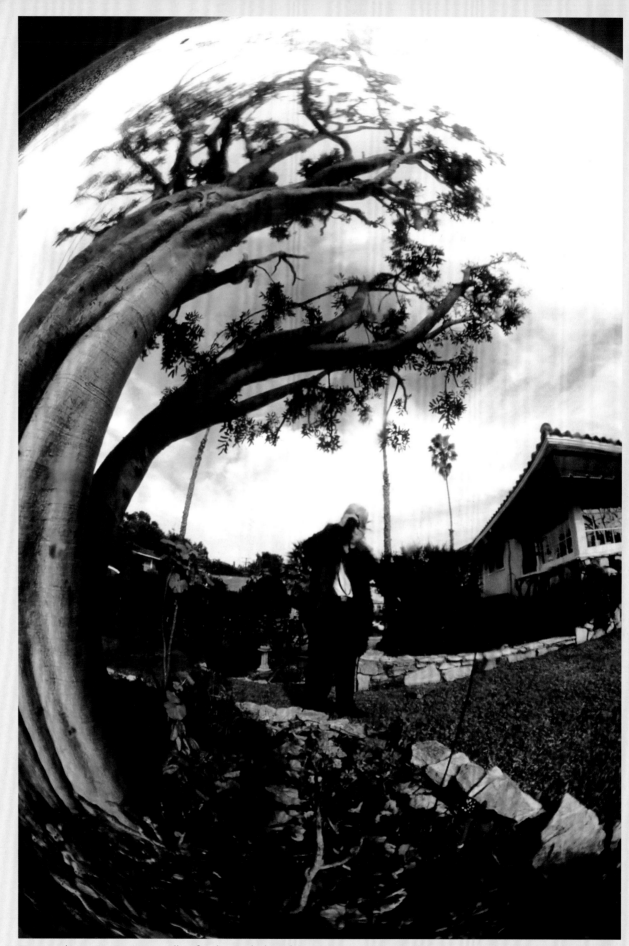

*Try something new. Again we walk a fine line; style depends on consistency, yet we need diversity. Periodically, new ideas need to be explored, even if they are one-time ventures. This image serves multiple purposes; it shows that I am willing to experiment, and that unique shots can be made in your own front yard. Then, finally, it allows me to present myself to you via a self portrait.*

Do not try to organize your backlog in giant time slots. If you force yourself to do too much at one sitting, you will never complete the task. How do you eat an elephant? One bite at a time. Tell yourself that you will only tackle this giant project for a reasonable length of time, and always stop before tedium sets in. Once you discover that you are making headway, the task will no longer seem insurmountable. I used multiple cardboard boxes, so that once I made a rough date grouping, I could store the divisions in a way that allowed me to pick up where I left off last time.

Persevere. Organizing existing images will take time, but once you have things in reasonable order, move on. However, learning composition is a never-ending goal. The experienced photographer must continue to learn or stagnate. The diligent worker will be rewarded. Remember that there will be setbacks along the way, but that has always been the case.

There is much to learn, and only so much can be gleaned from a book. Practice yields experience; new knowledge must be added to old, comfortable concepts. With the tips you learned here and your personal compositional experience, you should be well equipped to move into

uncharted territory. By that I mean your feelings about composition should be your prime motivator as you move forward.

I hope that I have led you through some of the confusing compositional maze. And I hope that I have proven that composition is not as nebulous as most people imagine. Along the way, I hope that you have enjoyed yourself, and not thought too badly about my sneaking in a pun now and then.

I can think of no better way to close than to repeat a Latin motto that Thomas Merton used to end "The Seven Storey Mountain," a book that is unrelated to our pursuit; but the sentiment applies to us: Sit finnis libri, non finnis quaedrendi. Let this be the end of the book, not the end of the search.

Paul Comon

**aberration**
An optical flaw in a lens that causes the image to be distorted or unclear.

**acuity**
The definition of an edge between two distinct elements in an image that can be measured objectively

**ambient light**
See available light.

**angle of view**
The area seen by a lens, usually measured in degrees across the diagonal of the film frame.

**anti-aliasing**
A technique that reduces or eliminates the jagged appearance of lines or edges in an image.

**aperture**
The opening in the lens that allows light to enter the camera. Aperture is usually described as an f/number. The higher the f/number, the smaller the aperture; and the lower the f/number, the larger the aperture.

**artifact**
Information that is not part of the scene but appears in the image due to technology. Artifacts can occur in film or digital images and include increased grain, flare, static marks, color flaws, noise, etc.

**artificial light**
Usually refers to any light source that doesn't exist in nature, such as incandescent, fluorescent, and other manufactured lighting.

**aspect ratio**
The ratio of the width of an image to its height, sometimes expresses as x:y.

**astigmatism**
An optical defect that occurs when an off-axis point is brought to focus as sagittal and tangential lines rather than a point.

**automatic exposure**
When the camera measures light and makes the adjustments necessary to create proper image density on sensitized media.

**automatic flash**
An electronic flash unit that reads light reflected off a subject (from either a preflash or the actual flash exposure), then shuts itself off as soon as ample light has reached the sensitized medium.

**automatic focus**
When the camera automatically adjusts the lens elements to sharply render the subject.

**available light**
The amount of illumination at a given location that applies to natural and artificial light sources but not those supplied specifically for photography. It is also called existing light or ambient light.

**backlight**
Light that projects toward the camera from behind the subject.

**backup**
A copy of a file or program made to ensure that, if the original is lost or damaged, the necessary information is still intact.

**barrel distortion**
A defect in the lens that makes straight lines curve outward away from the middle of the image.

**bit**
Binary digit. This is the basic unit of binary computation. See also, byte.

**bit depth**
The number of bits per pixel that determines the number of colors the image can display. Eight bits per pixel is the minimum requirement for a photo-quality color image.

**bounce light**
Light that reflects off of another surface before illuminating the subject.

**bracketing**
A sequence of pictures taken of the same subject but varying one or more exposure settings, manually or automatically, between each exposure.

**brightness**
A subjective measure of illumination. See also, luminance.

**buffer**
Temporarily stores data so that other programs, on the camera or the computer, can continue to run while data is in transition.

**built-in flash**
A flash that is permanently attached to the camera body. The built-in flash will pop up and fire in low-light situations when using the camera's automated exposure settings.

**built-in meter**
A light-measuring device that is incorporated into the camera body.

**bulb**
A camera setting that allows the shutter to stay open as long as the shutter release is depressed.

**byte**
A single group of eight bits that is processed as one unit. See also, bit.

**card reader**
Device that connects to your computer and enables quick and easy download of images from memory card to computer.

**CCD**
Charge Coupled Device. This is a common digital camera sensor type that is sensitized by applying an electrical charge to the sensor prior to its exposure to light. It converts light energy into an electrical impulse.

**chromatic aberration**
Occurs when light rays of different colors are focused on different planes, causing colored halos around objects in the image.

**chrominance**
A component of an image that expresses the color (hue and saturation) information, as opposed to the luminance (lightness) values.

**chrominance noise**
A form of artifact that appears as a random scattering of densely packed colored "grain." See also, luminance and noise.

**close-up**
A general term used to describe an image created by closely focusing on a subject. Often involves the use of special lenses or extension tubes. Also, an automated exposure setting that automatically selects a large aperture (not available with all cameras).

**CMOS**
Complementary Metal Oxide Semiconductor. Like CCD sensors, this sensor type converts light into an electrical impulse. CMOS sensors are similar to CCDs, but allow individual processing of pixels, are less expensive to produce, and use less power. See also, CCD.

**CMYK mode**
Cyan, magenta, yellow, and black. This mode is typically used in image-editing applications when preparing an image for printing.

**color balance**
The average overall color in a reproduced image. How a digital camera interprets the color of light in a scene so that white or neutral gray appear neutral.

**color cast**
A colored hue over the image often caused by improper lighting or incorrect white balance settings. Can be produced intentionally for creative effect.

**color space**
A mapped relationship between colors and computer data about the colors.

**CompactFlash (CF) card**
One of the most widely used removable memory cards.

**complementary colors**
In theory: any two colors of light that, when combined, emit all known light wavelengths, resulting in white light. Also, it can be any pair of dye colors that absorb all known light wavelengths, resulting in black.

**compression**
A method of reducing file size through removal of redundant data, as with the JPEG file format.

**contrast**
The difference between two or more tones in terms of luminance, density, or darkness.

**contrast filter**
A colored filter that lightens or darkens the monotone representation of a colored area or object in a black-and-white photograph.

**critical focus**
The most sharply focused plane within an image.

**cropping**
The process of extracting a portion of the image area. If this portion of the image is enlarged, resolution is subsequently lowered.

**dedicated flash**
An electronic flash unit that talks with the camera, communicating things such as flash illumination, lens focal length, subject distance, and sometimes flash status.

**default**
Refers to various factory-set attributes or features, in this case of a camera, that can be changed by the user but can, as desired, be reset to the original factory settings.

**depth of field**
The image space in front of and behind the plane of focus that appears acceptably sharp in the photograph.

**diaphragm**
A mechanism that determines the size of the lens opening that allows light to pass into the camera when taking a photo.

**digital zoom**
The cropping of the image at the sensor to create the effect of a telephoto zoom lens. The camera interpolates the image to the original resolution. However, the result is not as sharp as an image created with an optical zoom lens because the cropping of the image reduced the available sensor resolution.

**diopter**
A measurement of the refractive power of a lens. Also, it may be a supplementary lens that is defined by its focal length and power of magnification.

**dpi**
Dots per inch. Used to define the resolution of a printer, this term refers to the number of dots of ink that a printer can lay down in an inch.

**dynamic balance**
In reference to composition, the use of unequal elements to create pleasing asymmetrical compositions

**electronic flash**
A device with a glass or plastic tube filled with gas that, when electrified, creates an intense flash of light. Also called a strobe. Unlike a flash bulb, it is reusable.

**electronic rangefinder**
A system that utilizes the AF technology built into a camera to provide a visual confirmation that focus has been achieved. It can operate in either manual or AF focus modes.

**EXIF**
Exchangeable Image File Format. This format is used for storing an image file's interchange information.

## exposure

When light enters the camera and reacts with the sensitized medium. The term can also refer to the amount of light that strikes the light sensitive medium.

## extension tube

A hollow metal ring that can be fitted between the camera and lens. It increases the distance between the optical center of the lens and the sensor and decreases the minimum focus distance of the lens.

## Fibonacci Number Sequence

An integer in the infinite sequence 1, 1, 2, 3, 5, 8, 13,... of which the first two terms are 1 and 1, and each succeeding term is the sum of the two terms immediately preceding it.

## file format

The form in which digital images are stored and recorded, e.g., JPEG, RAW, TIFF, etc.

## filter

Usually a piece of plastic or glass used to control how certain wavelengths of light are recorded. A filter absorbs selected wavelengths, preventing them from reaching the light sensitive medium. Also, software available in image-processing computer programs can produce special filter effects.

## FireWire

A high speed data transfer standard that allows outlying accessories to be plugged and unplugged from the computer while it is turned on. Some digital cameras and card readers use FireWire to connect to the computer. FireWire transfers data faster than USB. See also, Mbps.

## firmware

Software that is permanently incorporated into a hardware chip. All computer-based equipment, including digital cameras, use firmware of some kind.

## flare

Unwanted light streaks or rings that appear in the viewfinder, on the recorded image, or both. It is caused by extraneous light entering the camera during shooting. Diffuse flare is uniformly reflected light that can lower the contrast of the image. Zoom lenses are susceptible to flare because they are comprised of many elements. Filters can also increase flare. Use of a lens hood can often reduce this undesirable effect.

## focal length

When the lens is focused on infinity, it is the distance from the optical center of the lens to the focal plane.

## focal plane

The plane on which a lens forms a sharp image. Also, it may be the film plane or sensor plane.

## focus

An optimum sharpness or image clarity that occurs when a lens creates a sharp image by converging light rays to specific points at the focal plane. The word also refers to the act of adjusting the lens to achieve optimal image sharpness.

## FP high-speed sync

Focal Plane high-speed sync. Some digital cameras emulate high shutter speeds by switching the camera sensor on and off rather than moving the shutter blades or curtains that cover it. This allows flash units to be synchronized at shutter speeds higher than the standard sync speed. In this flash mode, the level of flash output is reduced and, consequently, the shooting range is reduced.

## frontlight

Light that projects toward the subject from the direction of the camera.

## f/stop

The size of the aperture or diaphragm opening of a lens, also referred to as f/number or stop. The term stands for the ratio of the focal length (f) of the lens to the width of its aperture opening. (f/1.4 = wide opening and f/22 = narrow opening.) Each stop up (lower f/number) doubles the amount of light reaching the sensitized medium. Each stop down (higher f/number) halves the amount of light reaching the sensitized medium.

## full-frame

The maximum area covered by the sensitized medium.

## full-sized sensor

A sensor in a digital camera that has the same dimensions as a 35mm film frame (24 x 36 mm).

## gigabyte

Just over one billion bytes.

## golden mean

see golden ratio

## golden ratio

The following irrational number and numerical approximation: 1.618033989 is known as the golden ratio or golden mean.

## golden rectangle

A rectangle whose side lengths are in the golden ratio; i.e. 1:1.618033989.

## gray card

A card used to take accurate exposure readings. It typically has a white side that reflects 90% of the light and a gray side that reflects 18%.

## gray scale

A successive series of tones ranging between black and white, which have no color.

## guide number

A number used to quantify the output of a flash unit. It is derived by using this formula: GN = aperture x distance. Guide numbers are expressed for a given ISO film speed in either feet or meters.

## histogram

A graphic representation of image tones.

## hot shoe

An electronically connected flash mount on the camera body. It enables direct connection between the camera and an external flash, and synchronizes the shutter release with the firing of the flash.

**icon**
A symbol used to represent a file, function, or program.

**image-processing program**
Software that allows for image alteration and enhancement.

**infinity**
In photographic terms, the theoretical most distant point of focus.

**interpolation**
Process used to increase image resolution by creating new pixels based on existing pixels. The software intelligently looks at existing pixels and creates new pixels to fill the gaps and achieve a higher resolution.

**ISO**
From ISOS (Greek for equal), a term for industry standards from the International Organization for Standardization. When an ISO number is applied to film, it indicates the relative light sensitivity of the recording medium. Digital sensors use film ISO equivalents, which are based on enhancing the data stream or boosting the signal.

**JPEG**
Joint Photographic Experts Group. This is a lossy compression file format that works with any computer and photo software. JPEG examines an image for redundant information and then removes it. It is a variable compression format because the amount of leftover data depends on the detail in the photo and the amount of compression. At low compression/high quality, the loss of data has a negligible effect on the photo. However, JPEG should not be used as a working format—the file should be reopened and saved in a format such as TIFF, which does not compress the image.

**kilobyte**
Just over one thousand bytes.

**latitude**
The acceptable range of exposure (from under to over) determined by observed loss of image quality.

**LCD**
Liquid Crystal Display, which is a flat screen with two clear polarizing sheets on either side of a liquid crystal solution. When activated by an electric current, the LCD causes the crystals to either pass through or block light in order to create a colored image display.

**LED**
Light Emitting Diode. It is a signal often employed as an indicator on cameras as well as on other electronic equipment.

**lens**
A piece of optical glass on the front of a c amera that has been precisely calibrated to allow focus.

**lens hood**
Also called a lens shade. This is a short tube that can be attached to the front of a lens to reduce flare. It keeps undesirable light from reaching the front of the lens and also protects the front of the lens.

**light meter**
Also called an exposure meter, it is a device that measures light levels and calculates the correct aperture and shutter speed.

**lithium-ion**
A popular battery technology (sometimes abbreviated to Li-ion) that is not prone to the charge memory effects of nickel-cadmium (Ni-Cd) batteries, or the low temperature performance problems of alkaline batteries.

**lossless**
Image compression in which no data is lost.

**lossy**
Image compression in which data is lost and, thereby, image quality is lessened. This means that the greater the compression, the lesser the image quality.

**low-pass filter**
A filter designed to remove elements of an image that correspond to high-frequency data, such as sharp edges and fine detail, to reduce the effect of moiré. See also, moiré.

**luminance**
A term used to describe directional brightness. It can also be used as luminance noise, which is a form of noise that appears as a sprinkling of black "grain." See also, brightness, chrominance, and noise.

**macro lens**
A lens designed to be at top sharpness over a flat field when focused at close distances and reproduction ratios up to 1:1.

**main light**
The primary or dominant light source. It influences texture, volume, and shadows.

**Mbps**
Megabits per second. This unit is used to describe the rate of data transfer. See also, megabit.

**megabit**
One million bits of data. See also, bit.

**megabyte**
Just over one million bytes.

**megapixel**
A million pixels.

**memory**
The storage capacity of a hard drive or other recording media.

**memory card**
A solid state removable storage medium used in digital devices. They can store still images, moving images, or sound, as well as related file data. There are several different types, including CompactFlash, SmartMedia, and xD, or Sony's proprietary Memory Stick, to name a few. Individual card capacity is limited by available storage as well as by the size of the recorded data (determined by factors such as image resolution and file format). See also, CompactFlash (CF) card, file format.

**menu**
A listing of features, functions, or options displayed on a screen that can be selected and activated by the user.

**microdrive**
A removable storage medium with moving parts. They are miniature hard drives based on the dimensions of a CompactFlash Type II card. Microdrives are more susceptible to the effects of impact, high altitude, and low temperature than solid-state cards are. See also, memory card.

**middle gray**
Halfway between black and white, it is an average gray tone with 18% reflectance. See also, gray card.

**midtone**
The tone that appears as medium brightness, or medium gray tone, in a photographic print.

**mode**
Specified operating conditions of the camera or software program.

**moiré**
Occurs when the subject has more detail than the resolution of the digital camera can capture. Moiré appears as a wavy pattern over the image.

**noise**
The digital equivalent of grain. It is often caused by a number of different factors, such as a high ISO setting, heat, sensor design, etc. Though usually undesirable, it may be added for creative effect using an image-processing program. See also, chrominance noise and luminance.

**operating system (OS)**
The system software that provides the environment within which all other software operates.

**overexposed**
When too much light is recorded with the image, causing the photo to be too light in tone.

**pan**
Moving the camera to follow a moving subject. When a slow shutter speed is used, this creates an image in which the subject appears sharp and the background is blurred.

**perspective**
The effect of the distance between the camera and image elements upon the perceived size of objects in an image. It is also an expression of this three-dimensional relationship in two dimensions.

**pincushion distortion**
A flaw in a lens that causes straight lines to bend inward toward the middle of an image.

**pixel**
Derived from picture element. A pixel is the base component of a digital image. Every individual pixel can have a distinct color and tone.

**plug-in**
Third-party software created to augment an existing software program.

**polarization**
An effect achieved by using a polarizing filter. It minimizes reflections from non-metallic surfaces like water and glass and saturates colors by removing glare. Polarization often makes skies appear bluer at 90 degrees to the sun. The term also applies to the above effects simulated by a polarizing software filter.

**pre-flashes**
A series of short duration, low intensity flash pulses emitted by a flash unit immediately prior to the shutter opening. These flashes help the TTL light meter assess the reflectivity of the subject. See also, TTL.

**RAM**
Stands for Random Access Memory, which is a computer's memory capacity, directly accessible from the central processing unit.

**RAW**
An image file format that has little or no internal processing applied by the camera. It contains 12-bit color information, a wider range of data than 8-bit formats such as JPEG.

**RAW+JPEG**
An image file format that records two files per capture; one RAW file and one JPEG file.

**rear curtain sync**
A feature that causes the flash unit to fire just prior to the shutter closing. It is used for creative effect when mixing flash and ambient light.

**red-eye reduction**
A feature that causes the flash to emit a brief pulse of light just before the main flash fires. This helps to reduce the effect of retinal reflection.

**resolution**
The amount of data available for an image as applied to image size. It is expressed in pixels or megapixels, or sometimes as lines per inch on a monitor or dots per inch on a printed image.

**RGB mode**
Red, Green, and Blue. This is the color model most commonly used to display color images on video systems, film recorders, and computer monitors. It displays all visible colors as combinations of red, green, and blue. RGB mode is the most common color mode for viewing and working with digital files onscreen.

**saturation**
The degree to which a color of fixed tone varies from the neutral, grey tone; low saturation produces pastel shades whereas high saturation gives pure color.

**sharp**
A term used to describe the quality of an image as clear, crisp, and perfectly focused, as opposed to fuzzy, obscure, or unfocused.

**short lens**
A lens with a short focal length—a wide-angle lens. It produces a greater angle of view than you would see with your eyes.

**shutter**
The apparatus that controls the amount of time during which light is allowed to reach the sensitized medium.

**sidelight**
Light that projects toward either side of the subject.

**slow sync**
A flash mode in which a slow shutter speed is used with the flash in order to allow low-level ambient light to be recorded by the sensitized medium.

**SLR**
Single-lens reflex. A camera with a mirror that reflects the image entering the lens through a pentaprism or pentamirror onto the viewfinder screen. When you take the picture, the mirror reflexes out of the way, the focal plane shutter opens, and the image is recorded.

**small-format sensor**
In a digital camera, this sensor is physically smaller than a 35mm frame of film. The result is that standard 35mm focal lengths act like longer lenses because the sensor sees an angle of view smaller than that of the lens.

**standard lens**
Also known as a normal lens, this is a fixed-focal-length lens usually in the range of 45 to 55mm for 35mm format (or the equivalent range for small-format sensors). In contrast to wide-angle or telephoto lenses, a standard lens views a realistically proportionate perspective of a scene.

**stop up**
To increase the size of the diaphragm opening by using a lower f/number.

**strobe**
Abbreviation for stroboscopic. An electronic light source that produces a series of evenly spaced bursts of light.

**synchronize**
Causing a flash unit to fire simultaneously with the complete opening of the camera's shutter.

**telephoto effect**
When objects in an image appear closer than they really are through the use of a telephoto lens.

**telephoto lens**
A lens with a long focal length that enlarges the subject and produces a narrower angle of view than you would see with your eyes.

**thumbnail**
A small representation of an image file used principally for identification purposes.

**TIFF**
Tagged Image File Format. This popular digital format uses lossless compression.

**tripod**
A three-legged stand that stabilizes the camera and eliminates camera shake caused by body movement or vibration. Tripods are usually adjustable for height and angle.

**TTL**
Through-the-Lens, i.e. TTL metering.

**Tv**
Time Value. See Shutter-priority mode.

**USB**
Universal Serial Bus. This interface standard allows outlying accessories to be plugged and unplugged from the computer while it is turned on. USB 2.0 enables high-speed data transfer.

**vignetting**
A reduction in light at the edge of an image due to use of a filter or an inappropriate lens hood for the particular lens.

**viewfinder screen**
The ground glass surface on which you view your image.

**wide-angle lens**
A lens that produces a greater angle of view than you would see with your eyes, often causing the image to appear stretched. See also, short lens.

**Wi-Fi**
Wireless Fidelity, a technology that allows for wireless networking between one Wi-Fi compatible product and another.

**zoom lens**
A lens that can be adjusted to cover a wide range of focal lengths.

# index